EDINBURGH PUBS

JACK GILLON

AMBERLEY

First published 2016

Amberley Publishing
The Hill, Stroud
Gloucestershire, GL5 4EP

www.amberley-books.com

Copyright © Jack Gillon, 2016
Maps contain Ornance Survey data.
Crown Copyright and database right, 2016

The right of Jack Gillon to be identified as
the Author of this work has been asserted in
accordance with the Copyrights, Designs and
Patents Act 1988.

ISBN: 978 1 4456 5259 7 (print)
ISBN: 978 1 4456 5260 3 (ebook)

British Library Cataloguing in Publication Data.
A catalogue record for this book is available from
the British Library.

Typesetting by Amberley Publishing.
Printed in the UK.

Contents

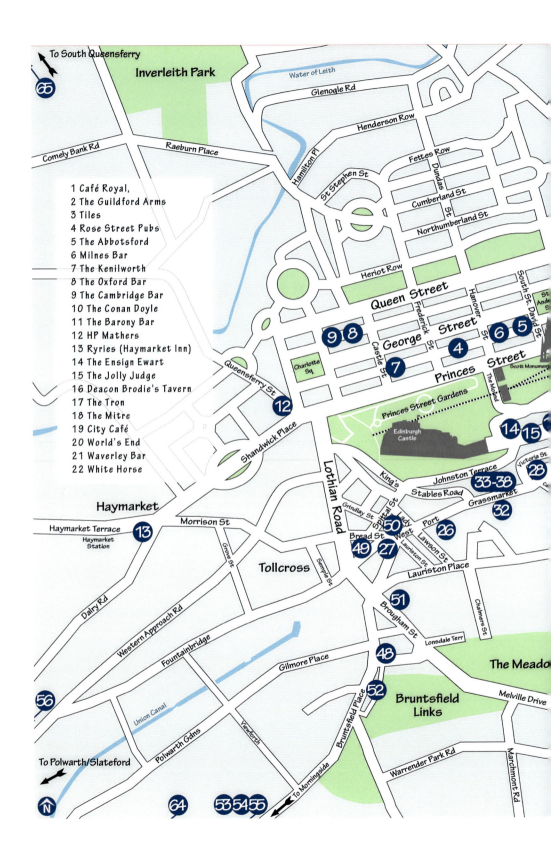

To South Queensferry

Inverleith Park

Water of Leith

Glenogle Rd

Henderson Row

Comely Bank Rd

Raeburn Place

Fettes Row

Hamilton Pl

St Stephen St

Dundas St

Cumberland St

Dublin St

Northumberland St

1 Café Royal,
2 The Guildford Arms
3 Tiles
4 Rose Street Pubs
5 The Abbotsford
6 Milnes Bar
7 The Kenilworth
8 The Oxford Bar
9 The Cambridge Bar
10 The Conan Doyle
11 The Barony Bar
12 HP Mathers
13 Ryries (Haymarket Inn)
14 The Ensign Ewart
15 The Jolly Judge
16 Deacon Brodie's Tavern
17 The Tron
18 The Mitre
19 City Café
20 World's End
21 Waverley Bar
22 White Horse

Heriot Row

Queen Street

Hanover St

South St David St

St Andrew Sq

Frederick St

George Street

Castle St

Charlotte Sq

Queensferry St

Princes Street

Scott Monument

The Mound

Shandwick Place

Princes Street Gardens

Edinburgh Castle

King's Stables Road

Johnston Terrace

Victoria St

Grassmarket

Haymarket

Haymarket Terrace

Haymarket Station

Morrison St

Grove St

Lothian Road

Grindlay St

Spittal St

Lady Lawson St

Bread St

West Port

Lauriston St

Lauriston Place

Lawson St

Tollcross

Semple St

Chalmers St

Brougham St

Lonsdale Terr

Dalry Rd

Western Approach Rd

Fountainbridge

Gilmore Place

The Meadows

Melville Drive

Union Canal

Bruntsfield Place

Bruntsfield Links

To Polwarth/Slateford

Polwarth Gdns

Viewforth

To Morningside

Warrender Park Rd

Marchmont Rd

N

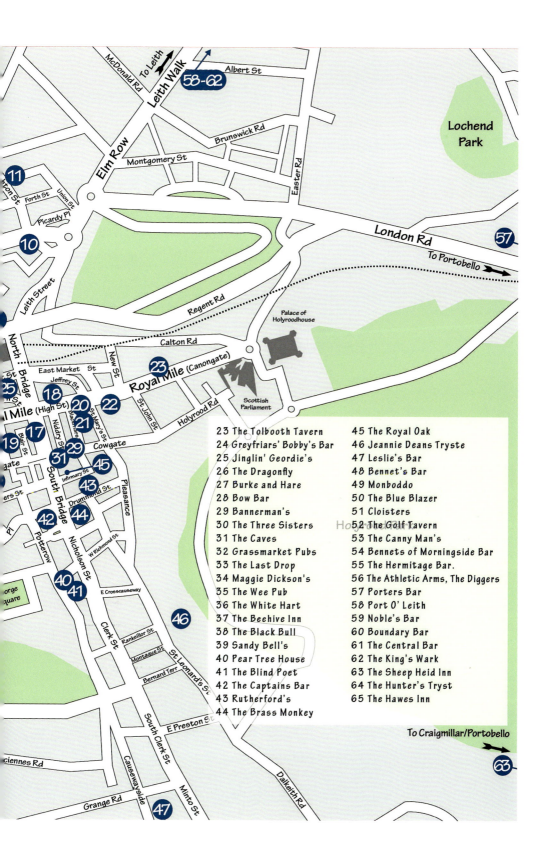

Lochend Park

58-62

Albert St

To Leith

Leith Walk

McDonald Rd

Elm Row

Brunswick Rd

Montgomery St

Easter Rd

11

Forth St

Union St

Picardy Pl

10

London Rd

57

To Portobello

Leith Street

Regent Rd

Palace of Holyroodhouse

North Bridge

Calton Rd

East Market St

New St

Jeffrey St

23

Royal Mile (Canongate)

St Mary's St

St John St

Holyrood Rd

Scottish Parliament

25

18

20

22

St John St

Royal Mile (High St)

17

Niddry St

St Mary's St

21

Blackfriars St

19

Blair St

29

Cowgate

31

45

Infirmary St

43

Drummond St

Pleasance

42

44

South Bridge

Nicholson St

Potterow

W Richmond St

40

41

E Crosscauseway

George Square

46

Clerk St

Rankeillor St

Montague St

St Leonard's St

Bernard Terr

South Clerk St

E Preston St

To Craigmillar/Portobello

63

Causewayside

ciennes Rd

Grange Rd

Minto St

Dalkeith Rd

47

23 The Tolbooth Tavern	45 The Royal Oak
24 Greyfriars' Bobby's Bar	46 Jeannie Deans Tryste
25 Jinglin' Geordie's	47 Leslie's Bar
26 The Dragonfly	48 Bennet's Bar
27 Burke and Hare	49 Monboddo
28 Bow Bar	50 The Blue Blazer
29 Bannerman's	51 Cloisters
30 The Three Sisters	52 The Golf Tavern
31 The Caves	53 The Canny Man's
32 Grassmarket Pubs	54 Bennets of Morningside Bar
33 The Last Drop	55 The Hermitage Bar.
34 Maggie Dickson's	56 The Athletic Arms, The Diggers
35 The Wee Pub	57 Porters Bar
36 The White Hart	58 Port O' Leith
37 The Beehive Inn	59 Noble's Bar
38 The Black Bull	60 Boundary Bar
39 Sandy Bell's	61 The Central Bar
40 Pear Tree House	62 The King's Wark
41 The Blind Poet	63 The Sheep Heid Inn
42 The Captains Bar	64 The Hunter's Tryst
43 Rutherford's	65 The Hawes Inn
44 The Brass Monkey	

Acknowledgements

Thanks to all the pub landlords and bar staff who helped with information and access for the photos. I owe a huge debt of thanks to celebrated local artist Ross Macintyre for the evocative paintings of the pubs which are included in the book. You can see more of Ross's vibrant watercolours of Edinburgh scenes, landscapes, cityscapes, trees and flowers at http://www.rossmacintyre.co.uk/. Special thanks to Murray Wilson for the map. Finally, a big thank you to Emma Jane for her continuing support.

Introduction

Auld Reekie! wale o' ilka toon
That Scotland kens beneath the moon;
Where coothy chields at e'enin' meet,
Their bizzin' ciaigs and mous to weet,
And blithely gar auld care gae by,
Wi' blinkin' and wi' bleerin' eye.

Robert Fergusson

Tavern dissipation, now so rare amongst the respectable classes of the community, formerly prevailed in Edinburgh to an incredible extent, and engrossed the leisure hours of all professional men, scarcely excepting even the most stern and dignified. No rank, class, or profession, indeed, formed an exception to this rule. Nothing was so common in the morning as to meet men of high rank and official dignity reeling home from a close in the High Street, where they had spent the night in drinking. Nor was it unusual to find two or three of His Majesty's most honourable Lords of Council and Session mounting the bench in the forenoon in a crapulous state.

Robert Chambers, *Traditions of Edinburgh*, 1868

Pubs have been the main focus of conviviality in Edinburgh for centuries and have played an indispensable part in the life of the city. It was the teeming nature of life in eighteenth century Edinburgh that elevated the Old Town's taverns to a critical role in the city's social life and there was 'no superabundance of sobriety in the town' – in 1740, there were no fewer than 240 premises with drink licenses in the Old Town. 'Intemperance was the rule and no man of the day thought himself able to dispense with the Meridian' (the drink taken at midday) – a 'cauld cock and a feather' was the euphemism for a glass of brandy and a bunch of raisins, a particular favourite at the Meridian. Much of the business life of the city was carried out in taverns and it was even normal for doctors to consult their patients in a laigh house.

Much of the Bacchanalian revelry centred on the many dining and drinking clubs that thrived in the town. Many of these were quite civilised, allowing like-minded

individuals to get together in a tavern, have a few glasses of ale and share a common interest. However, some were notorious – the young blades of the Sweating Club would get as intoxicated as possible while still able to stand and head out at midnight to assault innocent passers-by, chasing and jostling them until they perspired. According to Robert Chambers in his *Traditions of Edinburgh*, in the early years of the nineteenth century 'it was unsafe to walk the streets of Edinburgh at night on account of the numerous drunken parties of young men who then reeled about, bent on mischief, at all hours, and from whom the Town Guard were unable to protect the sober citizen'.

The Edinburgh taverns of the eighteenth century were 'in courts and closes away from the public thoroughfare and often presented narrow and stifling accommodation'. They had a 'coarse and darksome snugness which was courted by their worshippers'.

Although the cleanliness of Luckie Wood's, a famous old Edinburgh tavern, near the Watergate, is celebrated in these lines by Allan Ramsay:

> She gaed as feat as a new preen,
> And kept her housie snod and bien,
> Her pewther glanc'd upo' your een Like siller plate;
> She was a sonsie wife and clean, Without debate.

JOHNNIE DOWIE'S TAVERN

One of the most popular hostelries in eighteenth-century Edinburgh was Johnnie Dowie's Tavern in Libberton's Wynd, a narrow lane sloping down to the Cowgate, just to the east of the junction of the present-day High Street and George IV Bridge. This 'perfect specimen of tavern' was run by 'Dainty' Johnnie Dowie. The most eminent citizens and visitors, including Robert Fergusson, David Hume and Burns, frequented Dowie's 'quaint house of entertainment for its congenial company and good fare'.

The following description of Dowie's was typical of the taverns of the day: 'a great portion of this house was without light, consisting of a series of windowless chambers,

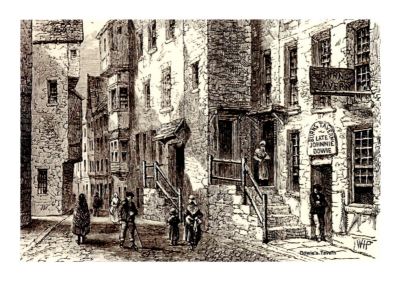

Johnnie Dowie's Tavern.

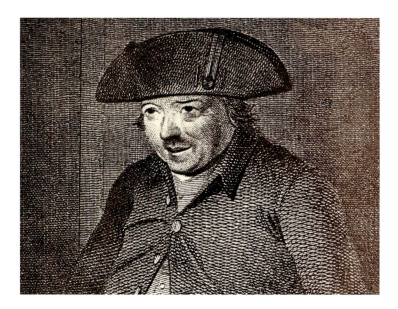

Johnnie Dowie.

decreasing in size till the smallest was a mere box, of irregular oblong shape, designated the Coffin'. The largest room could accommodate fourteen people, the Coffin held four, at a squeeze, and only two of the rooms had windows. The Coffin was reputedly much favoured by Burns and it was here that he is said to have composed many of his best songs.

Dowie's was renowned for its Archibald Younger's Edinburgh Ale, 'a potent fluid which almost glued the lips of the drinker together and of which few could despatch more than a bottle' and was also famed for its 'petit soupers', the speciality of the house being Nor' Loch eel pie.

Dowie circulated the following verses in honour of his tavern which he ascribed to Burns:

Johnnie Dowie's Ale

A' ye wha wis', on e'enings lang,
To meet an' crack, and sing a sang,
And weet your pipes, for little wrang,
To purse or person,
To sere Johnnie Dowie's gang,
There thrum a verse on.

O, Dowie's ale! Thou art the thing,
That gars us crack, and gars us sing,
Cast by our cares, our wants a' fling
Fraw us wi' anger;
Thou e'en mak'st passion tak the wing,
Or thou wilt bang 'er.

How blest is he wha has a groat
To spare upon the cheering pot;
He may look blithe as ony Scot
　　That e'er was born:
Gie's a' the like, but wi' a coat,
　　And guide frae scorn.

But thinkna that strong ale alone
Is a' that's kept by dainty John;
Na, na; for in the place there's none,
　　Frae end to end,
For meat can set you better on,
　　Than can your friend.

Wi' looks a mild as mild can be,
An' smudgin' laugh, wi' winkin' e'e;
An' lowly bow down to his knee,
　　He'll say fu' douce,
'Whe, gentlemen, stay till I see,
　　What's i' the house.'

Anither bow, 'Deed, gif ye please,
Ye can get a bit toasted cheese,
A crum o' tripe, ham, dish o' pease,
　　(The season fittin',)
An egg, or, cauler frae from the seas,
　　A fleuk or whitin';

A nice beefsteak, or ye may get
A gude buff'd herring, reisted skate,
An' ingans, an' (tho' past its date),
　　A cut o' veal;
Ha, ha, it's no that unco late,
　　I'll do it weel.'

Then pray for's health this mony year,
Fresh three-'n-a-ha' penny, best o' beer,
That can (tho' dull) you brawly cheer-
　　Recant you week up;
An' gar you a' forget your wear-
　　Your sorrows seal up.

Johnnie Dowie was the 'sleekest and kindest of all landlords' and 'conscientious as to money matters'. He left a substantial fortune when he died in 1817. The new owner of the Tavern displayed on the signboard outside the premises the name 'Burns Tavern late Johnnie Dowie'; capitalising on the fame of the previous landlord and the link with Burns.

PALACE PUBS

The earlier basic taverns were swept away during the period 1880–1910, which is generally recognised as the golden age of pub design. New licensing regulations required any place selling alcohol to be licensed and the authorities encouraged open planning in pubs which, combined with the addition of island bars, enabled staff to closely supervise customers. The evils of drink were also associated with many social problems – the Edinburgh Temperance Society was formed in 1883. Pub owners responded by investing in extremely grand premises that moved their establishments upmarket from the dingy drinking dens of earlier years.

These new pubs were ornamented with an abundance of spectacular decoration to attract customers into their shining interiors: richly ornamented façades; brightly coloured tiles, which had the added advantage of being durable and easy to clean; richly carved wooden panelling; decorative glass; advertising mirrors, known as showcards; elaborate gantries (from an old Scottish word which meant a frame for holding barrels) for dispensing spirits, which are much more common in Scotland than

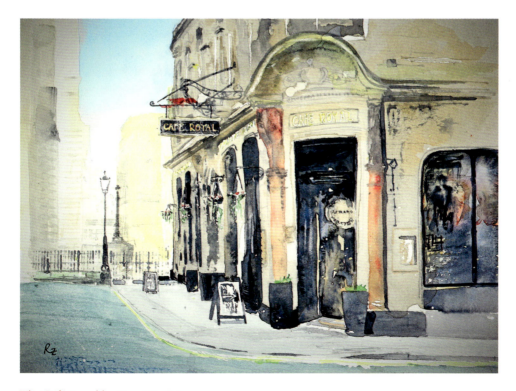

The Café Royal by Ross Macintyre.

in England due to the Scots' traditional preference for drinking whisky rather than beer; and sumptuous ornate plasterwork. They glistened at night offering a warm and welcome escape from the Scottish weather and often inferior housing conditions of the time. City centre pubs, which could attract the greatest number of customers, could meet the expense of the most grandiose schemes.

A number of architects specialised in work for the licensed trade. Peter Lyle Barclay Henderson (1848–1912) was particularly prolific. Henderson trained as both an architect and engineer and specialised in the design of breweries and public houses. He was responsible for many of Edinburgh's most elaborate pub interiors – such as the Abbotsford and Leslie's Bar. Robert McFarlane Cameron (1850–1920) was another architect who designed a number of fine pub interiors in Edinburgh. He was a Baillie and magistrate on the town council and was noted to be 'a firm friend of the licensed trade and as such secured a number of commissions for re-fitting pubs'.

Pubs operate in an aggressively competitive market and are subject to the vicissitudes of changing taste and fashions. From the 1970s, commercial pressures have unfortunately resulted in a large number of pubs being renovated and their historic interiors removed – often replaced with reproduction fittings. Those that remain are of special value and require appropriate protection.

The Scottish Government's Liquor Licensing statistics published in March 2015 show that Edinburgh has 1,147 premises with on-sale licences (around 10 per cent of the total for Scotland). Around 700 of these are pubs – one for every 700 inhabitants – the greatest concentration of drinking establishments per square mile than any other city in Europe. They range from centuries old traditional watering holes to chic new bars.

This book won't tell you how many real ales or malts the pubs stock or whether the burgers are worth popping in for. The intention is to provide a record of Edinburgh pubs which are architectural gems of exceptional quality or which have a particularly interesting historical association.

New Town

1. CAFÉ ROYAL, NO. 19 WEST REGISTER STREET

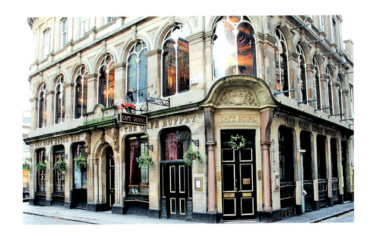

The Café Royal.

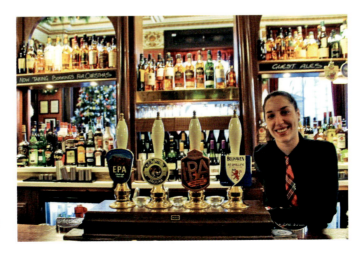

Claudia behind the bar at the Café Royal.

The Café Royal is Edinburgh's best and most celebrated pub. It is as splendid today as it was in the nineteenth century and its lavish interior reflects the heyday of the age of the most opulent Victorian pubs.

Edinburgh's first Café Royal opened in 1826 on the north side of West Register Street. The area was redeveloped in the 1860s and the original Café Royal was replaced by a building for the National Bank of Scotland. On 8 July 1863 an advert in *The Scotsman* announced the opening of the New Café Royal Hotel on Register Street. The property, designed by the architect Robert Paterson, had been built some two years earlier as a showroom for Robert Hume & Co., Plumbers and Gas Fitters. Its time as the New Café Royal Hotel continued to near the end of the nineteenth century.

Owners have made many changes to the layout of the pub over the years; but these have generally been of high quality, reflecting the original character and enriching the place in the process. In 1893, Alexander W. McNaughton, made alterations for the then owner, George McLaren. McNaughton was again involved with improvements for a new owner, Alexander Macpherson, in 1895. From 1898 to 1900, James MacIntyre Henry, made further extensive improvements which shaped the layout of the pub as it stands today.

The exterior is in an exuberant French style with intricate glazing, heavily moulded console brackets, a deeply set curly pediment on the corner entrance to the Oyster Bar and a steep mansard roof, which is noted as the first of its kind in Edinburgh.

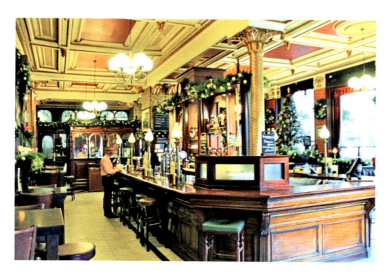

Café Royal Circle Bar.

The main Circle Bar has superb woodwork, a panelled dado, a white marble floor, a frieze decorated with ornate foliage motifs and a magnificent compartmented ceiling, with hanging bosses at the intersections. The marble fireplace, with an intricate over mantel, and the leather upholstered horseshoe seating areas are both original. The original island bar was sympathetically replaced in 1979 by an equally ornate one and a new high gantry was installed in 2002.

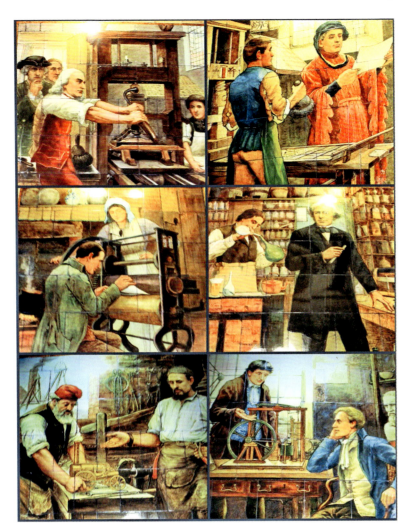

Café Royal – details of tiled panels.

The Circle Bar includes six Doulton tiled murals depicting famous inventors with the following details in an ornamental border: 'William Caxton, citizen of London who brought printing into England 1476'; 'Benjamin Franklin, printer distinguished in science and politics'; 'Robert Peel makes his first experiment in calico printing'; 'Michael Faraday, discoverer of electro-magnetism'; 'George Stephenson'; and 'James Watt inventor of the condensing engine & his partner Matthew Bolton'. They were painted by John Eyre and made by Katherine Sturgeon and W. J. W. Nunn. The murals were shown at the International Exhibition in the Meadows in 1886, from which they were purchased by then Café Royal licensee, J. McIntyre Henry.

The Oyster Bar is separated from the Circle Bar by an arcaded and columned walnut screen with engraved mirror panels, which dates from 1901. The Oyster Bar retains its original red marble counter and tiled panels on the bar front. It has been described as 'one of the grandest and also the most intimate of dining rooms in Britain'.

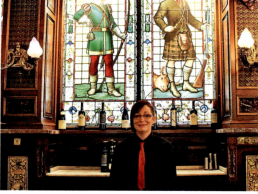

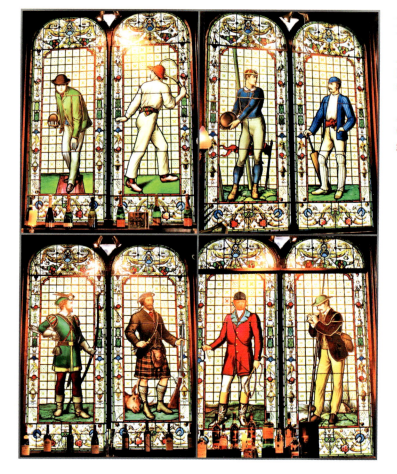

Above left: Café Royal Oyster Bar.

Above right: Ciara behind the bar at the Oyster Bar.

Left: Café Royal Oyster Bar stained glass.

There are another three tiled murals in the Oyster Bar depicting Louis J. M. Daguerre and Joseph Nicéphore Niépce, joint discoverers of photography, and two with a nautical theme – a Liverpool paddle steamer and the Clyde-built Cunard liner, *Umbria* – by Esther Lewis who was with the Doulton Company from 1880–95.

The eight spectacular stained glass windows in the Oyster Bar date from 1900 and depict British sports – bowls and tennis, archery and deerstalking, hunting and fishing, rugby and cricket. They were designed by J. Ballantine & Gardiner of No. 42 George Street, which also manufactured windows for the House of Lords at the Palace of Westminster.

The Café Royal came under threat in the late 1960s, when Woolworths proposed its demolition for an expansion of its shop at the east end of Princes Street. The massive public campaign against the redevelopment of this much cherished Edinburgh pub resulted in the building being listed in 1970 and its future secured for the enjoyment of generations to come.

2. THE GUILDFORD ARMS, NO. 1 WEST REGISTER STREET

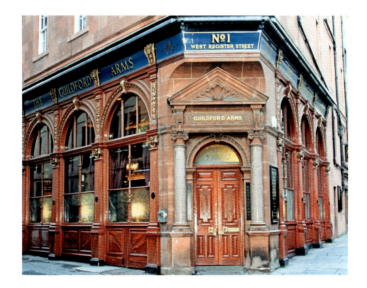

The Guildford Arms.

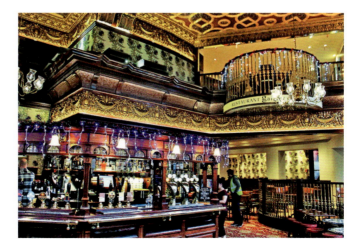

Inside the Guildford.

Next door to the Café Royal, the Guildford is another outstanding Victorian pub. Edinburgh is fortunate to have these two superb pubs in such close proximity.

The Guildford started life as a shop in the 1840s. In 1898, it was fitted out as a lavish pub with an elegant classical revival facade and a magnificent richly decorated Victorian Rococo interior with ornate cornices and an elaborate Jacobean painted ceiling. The owner at the time was James Dodds, who was also the proprietor of the Beehive Inn in the Grassmarket, and the architect was Robert MacFarlane Cameron. The Gallery Restaurant occupies an unusual mezzanine level above the back of the main double height bar area. The original ornate island bar was removed in 1940 and the present bar counter is a 1970's replacement. The pub has been run as a Free House by the Stewart family since its earliest days.

3. TILES, NO. 1 ST ANDREW SQUARE

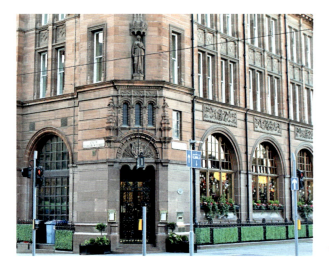

Tiles.

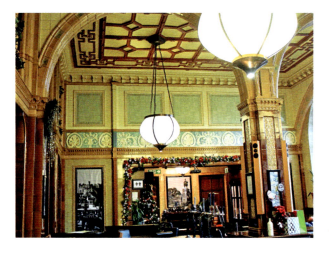

Tiles Interior.

Tiles occupies the ground floor of an imposing four-storey red sandstone building on the south east corner of St Andrew Square. The building dates from 1892–95 and was designed by Alfred Waterhouse and Son for the Prudential Insurance Company. Alfred Waterhouse (1830–1905) was one of the most financially successful architects of the Victorian period and was responsible for many significant buildings including the Manchester Town Hall and the Natural History Museum in London. The pub was established during the refurbishment of the building in 1993 and is entered through a door in the elaborate corner turret. The outstanding features of the pub are the ribbed plasterwork ceiling and the remarkable tiling which line the walls from floor to ceiling.

4. ROSE STREET PUBS

Rose Street pubs.

Rose Street runs parallel to Princes Street and George Street in Edinburgh's Georgian New Town. It has the greatest concentration of pubs in a straight line in the city and is known as the Amber Mile. The number of pubs has reduced from its heyday, but the long established Rose Street Challenge – having a drink in every establishment – remains a formidable test of endurance.

A number of Rose Street's esteemed drinking establishments have been lost to gentrification in recent years – many rugby fans will recall Paddy's Bar with affection. However, the street still retains a number of pubs which are among the best in the city for their architectural and historic importance.

5 THE ABBOTSFORD, NO. 3 ROSE STREET

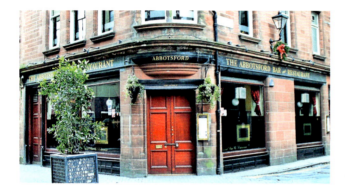

The Abbotsford.

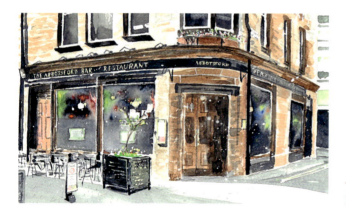

The Abbotsford by Ross Macintyre.

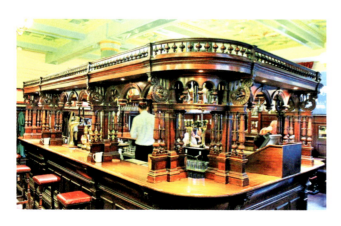

Inside the Abbotsford bar.

Maurizio behind the bar at the Abbotsford.

The splendid Abbotsford occupies a prominent turreted corner block with good Baronial details at the east end of Rose Street. The pub takes its name from the Borders' home of Sir Walter Scott.

An earlier pub called the Abbotsford Arms, on the opposite side of the street, was demolished for an expansion of Jenners' Department store and in 1902 Charles Jenner employed Peter Lyle Henderson to extend another of his properties, incorporating a new Abbotsford pub. It was a shrewd move, as the proximity of the pub to the Jenners' Department store meant that staff employed in the shop were likely to spend their money in his pub.

The entrance to the pub is through timber-panelled lobby doors with glass panels etched with 'The Abbotsford'. The interior fittings are essentially unaltered from the original scheme.

The luxuriantly carved central island mahogany bar counter divides the bar into small serving ports and supports an elaborate balustraded shelf from which spirits are dispensed. The extravagant compartmented ceiling is in a Jacobean-style.

An original smoking room and lounge at the rear of bar was removed for a staircase when the first floor was linked to the pub in the early 1970s. An original snack counter is an unusual survivor.

The beer is served from rare tall founts which pull the beer with air pressure and which are a uniquely Scottish method of dispensing cask-conditioned ale.

6. MILNE'S BAR, NO. 35 HANOVER STREET

Milne's Bar dates back to 1910, when it opened as a spirit merchants in the cellars of the building at No. 35 Hanover Street. By the 1950s, the premises had evolved into a pub known as Daddy Milne's. This was restricted to the cellar area until the 1980s, when it was expanded into the ground floor of the building with a frontage on Rose Street.

During the 1960s and '70s, Milne'\s became known as the Poets' Pub from its associations with the major poets and writers of the Scottish literary renaissance –

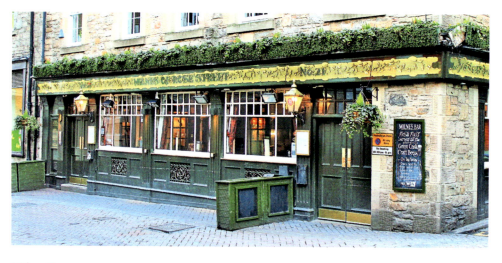

Milnes Bar.

Norman MacCaig, Hugh MacDiarmid, Sorley Maclean, Iain Crichton Smith, George Mackay Brown, Sydney Goodsir Smith, Edwin Morgan and Robert Garioch. The area where they congregated is now known as the Little Kremlin.

7. THE KENILWORTH, NOS 152–154 ROSE STREET

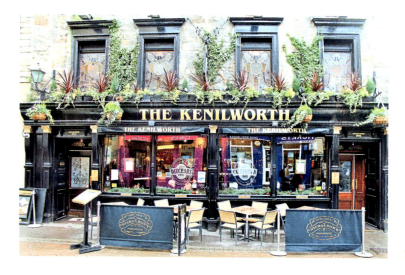

The Kenilworth.

The building which the Kenilworth occupies dates from the late eighteenth century and forms part of Edinburgh's original Georgian First New Town. The pub takes its name from a novel by Sir Walter Scott, who is depicted on the projecting sign that hangs on the pub frontage.

The well-detailed timber frontage dates from 1892 and was designed by Thomas Purves Marwick (1854–1927). The interior of this date was by the prolific pub designer, Peter L. B. Henderson.

The pub was significantly altered by Marwick in 1899 – the bar area was extended into a neighbouring property to the east; a striking double height interior was created, with a magnificent Jacobean compartmented ceiling, by extending into the first floor flat; an ornate island bar was fitted and the walls were decorated with embossed Minton tiles.

The Kenilworth was Marwick's only pub design, he is better known for his work for the Scottish Wholesale Co-operative Society. By the 1960s, the pub had been altered and the island bar counter had been removed. In 1966, the architects Covell Matthews sensitively restored the interior reinstating the island bar layout and restoring the decorative tiles.

8. THE OXFORD BAR, NO. 8 YOUNG STREET

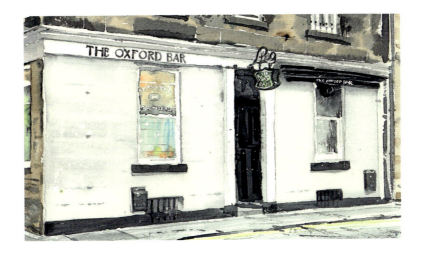

The Oxford Bar by Ross Macinytre.

The Oxford Bar (the 'Ox') first opened as a pub in 1811, although the premises are listed as a confectioner's in 1843. In 1893, it was taken over by Andrew Wilson, a wine and spirit merchant, and has been in continuous use as a pub since then.

The Oxford Bar has no fancy frontage – the only indications that it functions as a pub are some fairly inconspicuous signage and etched glass windows. The interior is also fairly basic consisting of a small stand-up bar to the front, with a late-nineteenth-century gantry, and an equally small sitting room at the back.

What the Oxford lacks in opulence is made up for by its literary associations. The pub has achieved international fame as the favourite watering hole of Ian Rankin's fictional detective John Rebus. A number of the regulars feature in the books and a Rebus' story by Rankin, which featured on the pub's website, starts with a body being found in the back lounge of the bar.

The pub also features in Sydney Goodsir Smith's 1947 comic novel, *Carotid Cornucopius*, which is set in Edinburgh and written in an inventive language, as the Coxfork in Bung Strait (in Goodsir's book the Abbotsford on Rose Street is the Abbotsfork on Low Street and Sandy Bells on Forrest Road is the Sunday Balls on Fairest Redd).

The pub is also famed for a former curmudgeonly landlord, Willie Ross, who was reluctant to serve ladies and Englishmen, and considered lager to be rather exotic. He also reputedly had a grudge against dogs and a prominent sign in the pub indicated that no dogs were allowed – this was due to an incident in 1962 when a dog had an accident under a seat in the bar.

9. THE CAMBRIDGE BAR, NO. 20 YOUNG STREET

The Cambridge Bar.

A few doors down from the Oxford, the Cambridge Bar occupies a smart two-storey building from 1779 which still has the appearance of a Georgian town house with domestic scaled windows – a couple of signs are the only indication that it is a pub. Once inside the domestic theme continues in this comfortable and cosy hostelry which is famed for its gourmet burgers.

10. THE CONAN DOYLE, NOS 71–73 YORK PLACE

The pub takes its name from Sir Arthur Conan Doyle (1859–1930) who was born in nearby Picardy Place. Doyle is commemorated by a larger-than-life-size statue of Sherlock Holmes, Doyle's great fictional detective, which was erected in 1991 outside the house in which he was born. The famous literary detective, is depicted meditating on the death of his author. His pipe is inscribed with the words 'Ceci n'est pas une pipe', in homage to the surrealist Magritte, and there is a footprint of a Hound of the Baskervilles on the bronze pedestal. The inscription reads: 'In Memory of Sir Arthur Conan Doyle, Born on 22 May 1859 Close to This Spot.'

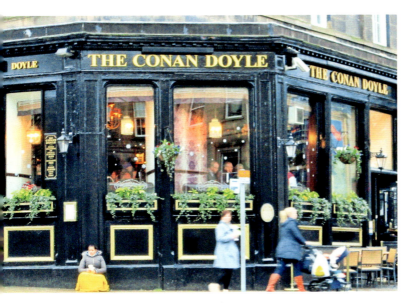

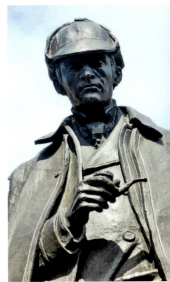

Above left: The Conan Doyle.

Above right: Statue of Sherlock Holmes.

11. THE BARONY BAR, NOS 81–85 BROUGHTON STREET

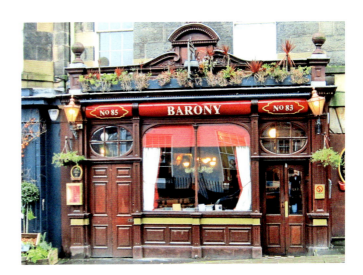

The Barony Bar

The Barony Bar forms the ground floor of an impressive four-storey tenement that dates from 1830. The bar was fitted out in 1898–99 by the architect and surveyor, John M. Forrester, who had his office at No. 39 Broughton Street. The pub was commissioned by the trustees of the estate of a Mr Sinclair, a deceased wine and spirit merchant.

The girls behind the bar at the Barony.

There is a lot going on with the fine classically detailed projecting timber-panelled teak frontage – a dentil cornice, scrolls, ball finials, balusters; all topped by a central ornate pediment. The welcoming interior retains a substantial amount of its original decorative scheme and is richly detailed with tiled fireplaces, fine cornices and large brewery mirrors. The oak bar and gantry reflect the rich detailing of the frontage. Colourful tiles on the dado panelling depict Scottish rural scenes.

West End

12. H. P. MATHERS, NO. 1 QUEENSFERRY STREET

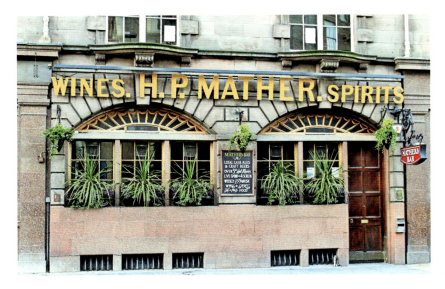

Mathers.

The striking five storey red ashlar building at the corner of Queensferry Street and Shandwick Place dates from 1901 and was designed by the prominent architectural practice of Sydney Mitchell & Wilson for the National Commercial Bank. The pub was designed by Arthur George Sydney Mitchell (1856–1930) for the wine merchant Hugh Mather and is largely unaltered.

The frontage consists of finely detailed rusticated stone with two wide arched mullioned windows. The polished red granite cladding below the windows was added in around 1939. Most of the original high quality interior decorative scheme survives. The elaborate compartmented ceiling with deeply moulded cornice and plaster frieze with birds and swags is particularly noteworthy.

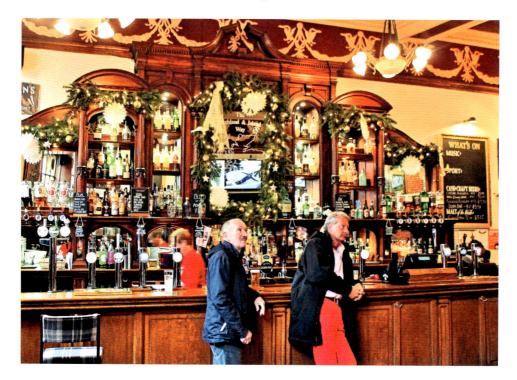

Inside Mathers.

13. RYRIES (HAYMARKET INN), NO. 1 HAYMARKET TERRACE

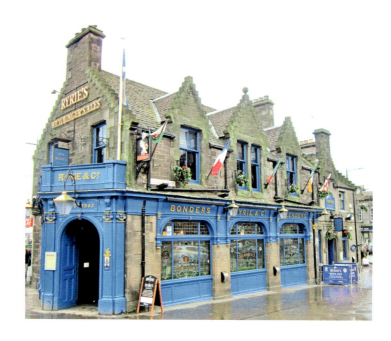

Ryries.

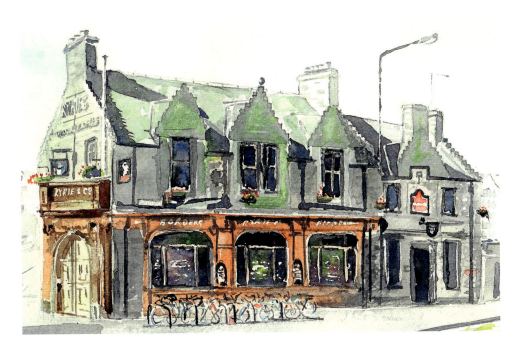

Ryries by Ross Macintyre.

Ryries is an attractive and largely unaltered Edwardian public house which occupies a prominent corner site at the junction of Dalry Road, Haymarket Terrace and Morrison Street, close to Haymarket Station which has always guaranteed the pub a steady flow of customers.

In the earlier part of the nineteenth century, the site was occupied by the Haymarket weigh house. Around the time that Haymarket Station was opened in 1942, it had become the Railway Inn. The Haymarket Inn was built slightly to the west of the corner in 1862 and Ryries was rebuilt in 1868 (the date that is shown on the cast-iron rainwater hoppers). The two separate establishments were linked and remodelled by Robert MacFarlane Cameron in 1906.

The building has fine Baronial detailing and an outstanding Scottish Renaissance timber frontage with elaborate leaded glass windows and lettering advertising – Spirits, Wines, Brandies, Cordials, McEwans 80s, Pale Ale. The interior is equally fine with a carved gantry incorporating mirrors, columns, decorative brackets and a central clock.

The Old Town

14. THE ENSIGN EWART, NOS 521–523 LAWNMARKET

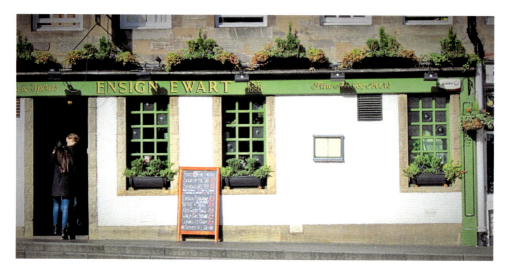

The Ensign Ewart.

The Ensign Ewart is the highest pub in Edinburgh and the closest to Edinburgh Castle. The pub's name celebrates Kilmarnock born Ensign Charles Ewart (1769–1846). Ewart was a Scottish soldier of the Royal North British Dragoons (the Scots Greys), who was famed for capturing the regimental eagle standard of the French 45th Regiment (the French Invincibles) at the Battle of Waterloo in 1815. Ewart was an expert swordsman and is described as being of 'Herculean strength'. He was hailed as a hero on his return and left the army in 1821. He lived in Salford, where he was buried in 1846. His grave was covered over and forgotten until the 1930s, when it was exhumed and his remains were reburied on Edinburgh Castle Esplanade. A simple block of Swedish Granite

inscribed with his name was erected to his memory on the Esplanade in April, 1938. The pub sign shows Ensign Ewart in uniform and the interior of the pub is decorated in a military theme with a painting showing the capture of the standard.

15. THE JOLLY JUDGE, JAMES COURT, NO. 493 LAWNMARKET

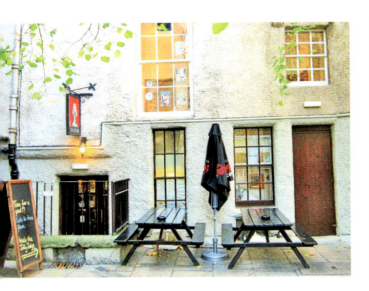
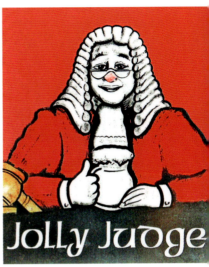

Above left: The Jolly Judge.

Above right: The Jolly Judge pub sign.

> O'er draughts of wine the writer penned the will,
> And legal wisdom counselled o'er a gill.

The expression 'as sober as a judge' seems to have been a bit of a misnomer in eighteenth century Edinburgh. According to accounts in Robert Chambers' *Traditions of Edinburgh*, members of the legal profession at the time were often strangers to sobriety. It was not uncommon for judges on the bench to consume a bottle of port while listening to the case before them and Lord Newton, who was famously fond of a drink, was found asleep in a chimney sweep's shed one Sunday morning, after a particularly wild night.

The Jolly Judge, is a cellar bar down a narrow close off the Lawnmarket, and is just the kind of place that one of these eighteenth-century members of the legal profession would have been found happily ensconced.

16. DEACON BRODIE'S TAVERN, NO. 435 LAWNMARKET

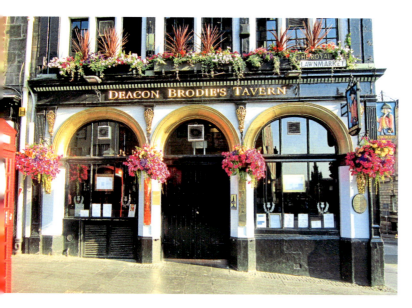
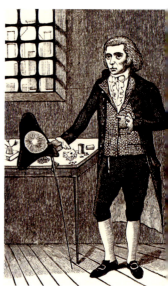

Above left: Deacon Brodie's.

Above right: Deacon Brodie.

Deacon Brodie's Tavern occupies a prominent site on Edinburgh's Royal Mile, at the corner of the Lawnmarket and Bank Street. The building dates from the early eighteenth century and the ground and first floors were fitted out as a pub by Edinburgh's most prolific pub architect, Peter Lyle Henderson, in 1894 for Donald Stewart. The arcade of three arched openings, bordered by ornate mouldings, to the frontage is particularly attractive and the interior features a compartmented ceiling with painted plasterwork roses and thistles.

Deacon William Brodie (1741–88) – model citizen by day and dissolute thief by night – was born into a respectable Edinburgh family, and rose to become Deacon of the Guild of Wrights and a Freeman of the city. He was considered an upstanding man of respectable connections who moved in good society all his life, unsuspected of any criminal pursuits. He was the proprietor of a locksmith and cabinet-making business in the Lawnmarket and this seemingly reputable façade concealed a private life which included a passion for cockfighting, two mistresses with five children between them and a predilection for gambling. These put him under considerable financial pressure which he relieved by carrying out a series of robberies on premises to which his trade as a locksmith had given him nefarious access. Brodie's downfall followed an armed raid on His Majesty's Excise Office on Edinburgh's Canongate. He escaped to the Netherlands but was eventually arrested in Amsterdam. In 1788, Brodie was hanged on the Tolbooth gallows, which he had designed himself. His double life was the inspiration for Robert Louis Stevenson's novel, *The Strange Case of Dr Jekyll and Mr Hyde*.

17. THE TRON, NO. 9 HUNTER SQUARE

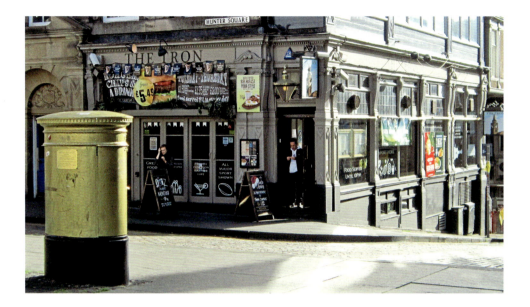

Above: The Tron.

Right: Traditional Hogmanay at the Tron.

The Tron Bar takes its name from the nearby seventeenth-century Tron Kirk. The Kirk was at one time the centre for Edinburgh's Hogmanay celebrations with thousands gathering around the building to listen for the Kirk's bells ringing in the New Year. The bells have not been working for decades and the centre for Edinburgh's New Year

festivities have moved to the street party in Princes Street. However, at the time of writing, there are plans to restore the Kirk's bells and bring the building back centre stage in Edinburgh's Hogmanay.

In the 1960s and '70s the pub went by the name The Yellow Carvel and was known as one of Edinburgh's chief folk music venues. The name derived from a ship, the Yellow Carvel, in which Sir Andrew Wood, 'Scotland's Nelson', won a famous sea battle in the Firth of Forth against the English, and the pub was decorated to resemble the deck of an old clipper with sailing sheets and netting. Following the Carvel's closure, the pub was transformed into the Ceilidh Club, and later to the Tron bar.

The gold painted post box at the front of the pub celebrates Chris Hoy's gold medal at the 2012 Olympic Games in the men's kierin.

18. THE MITRE, NOS 131–133 HIGH STREET

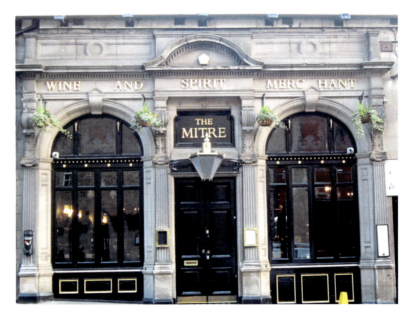

The Mitre.

The tall single-storey frontage of the Mitre dates from 1901 and was designed by Peter Lyle Barclay Henderson. It is finely detailed with symmetrical triple-arched window and entrance openings, fluted ionic pilasters and scrolled console brackets. The building was originally five storey and was reduced to single storey in the 1970s. Internally the bar has an ornate ribbed plaster ceiling and stretches a long way back.

The pub stands on the site of John Spottiswood's (1565–1639) Edinburgh home – an inscription on the Carrubber's Close side of the pub reads: 'House of Archbishop Spottiswood 1578 Rebuilt 1864' along with a carved bishop's mitre, the traditional ceremonial head-dress of bishops. Spottiswood was archbishop of St Andrews, primate of All Scotland, lord chancellor of Scotland and crowned Charles I at Holyrood in

1633. He supported attempts to enforce the Anglican Book of Common Prayer in Scotland which famously led to the protest at St Giles by Jenny Geddes and rioting on the streets of Edinburgh in 1637. Spottiswood fled the country after the riots. There are various legends of hauntings of the pub by the bishop.

19. CITY CAFÉ, NO. 19 BLAIR STREET

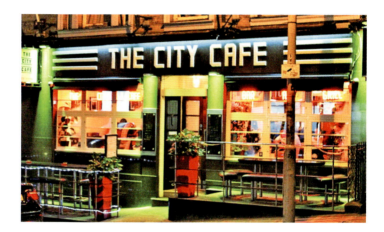

The City Café.

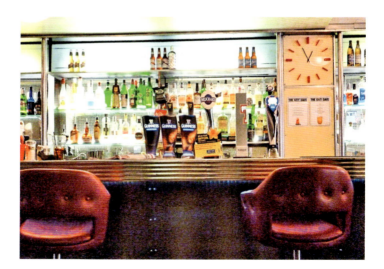

Inside the City Café.

The City Café is a pub which, with its stylish frontage and bar, has the feel of a retro American-style diner, even down to the burgers and pool table. The pub is famed for its Ultimate Burger Challenge – three beef burgers, two chicken breasts, two bean burgers, two pineapple rings, bacon, mushrooms, gherkins, guacamole, a plate sized bun, chips and coleslaw. Manage to clear the plate and it's free along with an Ultimate Burger Champion T-shirt and your photo on the Wall of Fame; failure means a bill for £30.

20. WORLD'S END, NO. 4 HIGH STREET

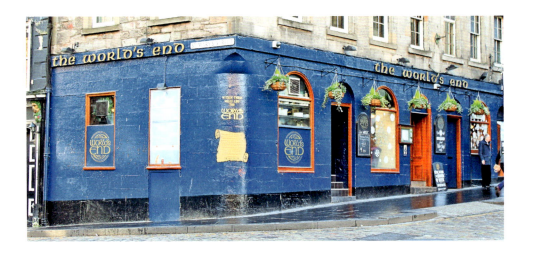

Above: The World's End.

Left: The Netherbow Port.

This popular bar on a prominent corner at the junction of the High Street and St Mary's Street takes its name from its location at the historic eastern extremity of Edinburgh. The Canongate, on the other side of St Mary's Street was a separate burgh from Edinburgh until 1856 with its own identity and character and, as late as the 1950s, Canongate residents would still refer to 'going up to Edinburgh', although the distance was measured in yards.

Brass plates set into the roadway outside of the pub mark the outline of the Netherbow Port which acted as the principal gateway into the old city of Edinburgh. It is mentioned as early as 1369, but a more elaborate version, with a two-storey spired tower above its main arched gateway, was conceived along with the Flodden Wall in 1513. It was also used as a crime-deterrent – the heads of executed criminals were gruesomely exhibited on the Netherbow. The demolition of the Netherbow Port went ahead in 1764, by order of the city magistrates – in the post-Culloden era, it was no longer required as a defensive structure, was widely regarded as an obstruction to the flow of traffic and as an out-dated restriction on free trade.

21. WAVERLEY BAR, NO. 1 ST MARYS STREET

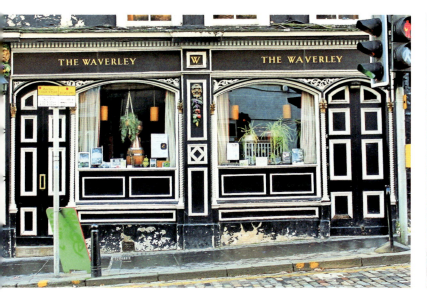 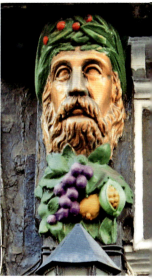

Above left: The Waverley.

Above right: Bacchus head detail.

The frontage of the Waverley is a rare and notable Victorian survivor from 1891. It is particularly finely detailed with arched openings, slender barley-sugar twist mullions and a deep dentil cornice. The outstanding features are the figurehead consoles depicting Bacchus, the God of Wine.

The Waverley has a legendary reputation in the folk music world, with the likes of the Incredible String Band, the Corries, and Bert Jansch cutting their teeth in the bar's upstairs lounge in the 1960s.

22. WHITE HORSE, NO. 266 CANONGATE

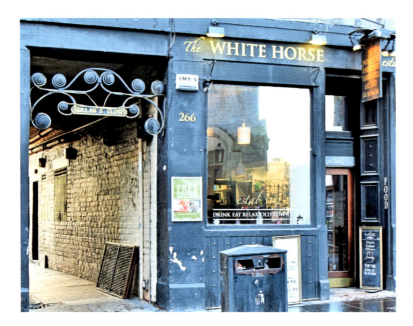

The White Horse.

A hostelry was established on the site of the White Horse as early as 1742. Previous establishments went by the name of Boyd's Inn, frequented by Boswell and Johnson, and the Glencoe. It is also one of the smallest, although a narrow corridor links the tiny front bar to a larger lounge to the rear.

Until 2010, it was one of the last old-boozers on the Royal Mile, where the licensees, Kath and Rab Will, had welcomed locals for over thirty years. Despite its makeover to attract a more tourist related clientele, the White Horse retains the atmosphere of a traditional Scottish bar.

23. THE TOLBOOTH TAVERN, NO. 167 CANONGATE

The Tolbooth Tavern occupies part of the historic Canongate Tolbooth which dates from 1591. The diminutive frontage of the pub belies a fairly large interior. It was established in 1820 and incorporated a section to the rear, which was originally built as a house.

The Canongate Tolbooth is a landmark feature on the Royal Mile and one the most distinctive and oldest buildings on the Canongate. It overflows with architectural detailing – turreted towers and a large projecting clock, which was added in 1884. It was the administrative base of the separate Canongate burgh and served as the centre of local administration and justice with a courthouse, burgh jail and meeting place for the town council. During the 1600s many captured Covenanters were held in the Tolbooth.

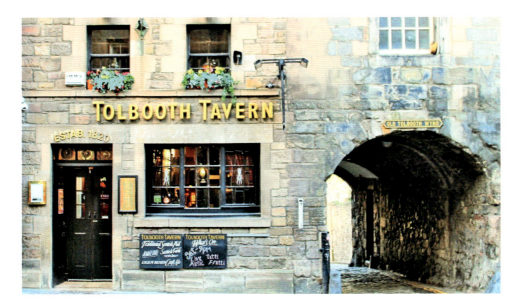

Above: The Tolbooth Tavern.

Right: The Tolbooth.

24. GREYFRIARS' BOBBY'S BAR, NOS 30–34 CANDLEMAKER ROW

Greyfriars' Bobby's Bar was fitted out as a pub in 1893 by the architectural firm of Dunn and Findlay. It occupies the ground floor of a two-storey early eighteenth-century building. The frontage of the pub retains much of its original character, however, the interior is largely modern.

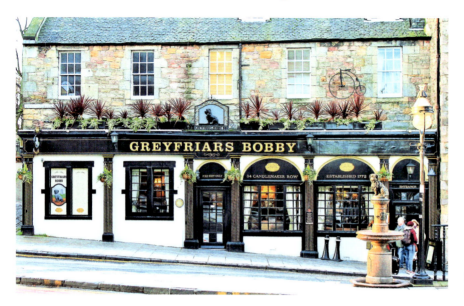

Greyfriars'
Bobby.

The name of the pub is inspired by Greyfriar's Bobby, a Skye terrier, which, legend has it, kept a vigil at the grave of his owner, John Gray, an Edinburgh policeman, in Greyfriar's Kirkyard between 1858 and 1872. The story was made famous by the 1961 Disney film.

The rear elevation of the pub forms the eastern boundary of Greyfriar's churchyard and Bobby is commemorated by a life sized bronze sculpture atop a fountain in front of the pub. The memorial to Bobby was unveiled on 15 November 1873 and was paid for by Baroness Angela Burdett-Coutts, the wealthy daughter of a former Edinburgh Lord Provost. The plaque on the fountain reads:

A Tribute to the Affectionate Fidelity of Greyfriar's Bobby. In 1858, This Faithful Dog Followed the Remains of His Master to Greyfriar's Churchyard and Lingered Near the Spot until His Death in 1872. With Permission, Erected by the Baroness Burdett-Coutts. Greyfriar's Bobby, From the Life Just Before His Death.

25. JINGLIN' GEORDIE'S, NO. 22 FLESHMARKET CLOSE

The steeply sloping Fleshmarket Close links Market Street to Cockburn Street in Edinburgh's Old Town. The close is shown on maps from as early as 1742 and takes its name from the meat market which moved from the south side of the Tron to the lower part of the slope down to the Nor' Loch prior to 1691.

The Jinglin' Geordie pub lies at the middle of the close and is named for George Heriot (1563–1624). Heriot trained in the family business as a Goldsmith and after completing his apprenticeship set up business in Edinburgh's Luckenbooths, which stood on the north side of St Giles. His business prospered and by 1588 he was elected to the town council and the Edinburgh Incorporation of Goldsmiths. One of his most regular customers was the jewellery loving Anne of Denmark, the wife of King James

Jinglin' Geordie's.

VI of Scotland. In 1597, he was appointed goldsmith to the Queen and to the King in 1601. In 1603, at the time of the Union of the Crowns, he moved to London with the Royal Court. His considerable wealth was based on his activities as a goldsmith and as a moneylender to the Royal family and their court. His nickname, 'Jinglin' Geordie', was based on the quantity of coins which he carried in his purse. In his will he left the bulk of his estate to establish the magnificent George Heriot's School for the education of the 'puir, faitherless bairns' of Edinburgh.

A statue of Heriot in the school quadrangle has a Latin inscription which translates as: 'This statue shows my body, this building shows my soul'. He is also shown holding a model of the school in a statue on the Scott Monument and his name is commemorated in the Heriot-Watt University.

The pub was the haunt of Scotsman journalists, when the newspaper office was in the building opposite. Jinglin' Geordie's extends over the Halfway House pub which is lower down the close. Both are very welcome hostelries on the steep climb up the Fleshmarket Close.

26. THE DRAGONFLY, NO. 52 WEST PORT

The Dragonfly occupies the ground floor of a building which dates from 1884 and which was built as a combined police and fire station with cells, an engine room and three floors of accommodation above.

The pub was previously appropriately known as the Fire Station and Braidwood's. James Braidwood (1800–1861) established the world's first municipal fire service in Edinburgh in 1824. Braidwood trained as a builder and surveyor before being appointed Edinburgh's master of fire engines at the age of twenty-four, just before the Great Fire of Edinburgh which raged for five days from 15 November 1824 and destroyed a large part of the High Street from St Giles to the Tron. He introduced

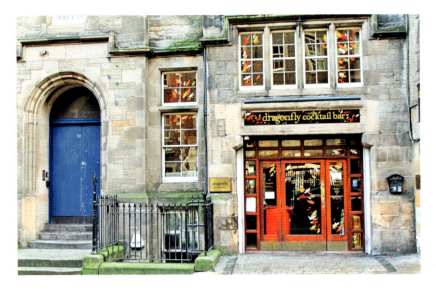

The Dragonfly.

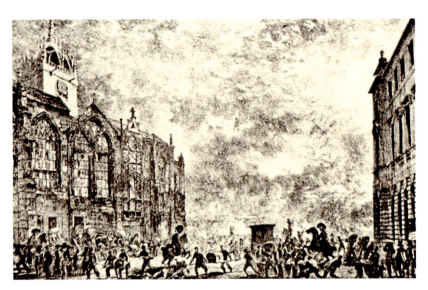

The Great Fire
of Edinburgh.

methods of fire-fighting that are still used today and is credited with the development of the modern municipal fire service. He was later appointed as the first director of what was to become the London Fire Brigade. Braidwood died fighting the Tooley Street fire at Cotton's Wharf in London on 22 June 1861, when he was crushed by a falling wall. He is commemorated by a statue in Parliament Square.

The fire station on the West Port was originally built to cover fires in the Grassmarket area and followed one of Braidwood's principles – it was located uphill from the area that it was intended to serve to allow easier and faster deployment of the heavy firefighting equipment.

27. BURKE & HARE, NO. 1 HIGH RIGGS

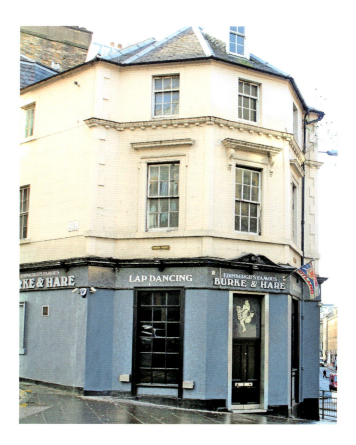

The Burke & Hare.

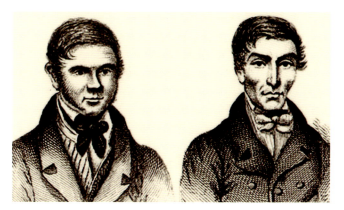

Burke & Hare.

The Burke and Hare is one of three pubs, along with the Western Bar and the No. 1 Show Bar, in the West Port area which make up Edinburgh's notorious 'Pubic Triangle' – so called because all three offer strip shows – and which are much frequented by stag parties.

Up the close and doun the stair,
But and ben wi' Burke and Hare.
Burke's the butcher, Hare's the thief,
Knox the boy that buys the beef.

Before the Anatomy Act of 1832, which expanded the legal supply of medical cadavers, there were insufficient bodies available for anatomical dissections in the medical schools. Executed criminals were the main source, but this had been reduced due to a decrease in executions in the early nineteenth century.

The medical schools came to rely on bodies which had been acquired by nefarious means and grave robbing by 'resurrectionists' became one of the main sources. This gave rise to particular public fear and watchtowers were set up in graveyards, so that relatives could watch over the graves of their relatives for such time that the bodies would no longer be of use for dissection.

Edinburgh's notorious Burke and Hare saw the potential profit in this, but rather than going to the hard work of grave robbing, they simply murdered their victims and sold the bodies to the Edinburgh Medical School for dissection. Over a period of a few months in 1828 they were responsible for the murders of seventeen victims, which shocked and terrified Edinburgh.

On their apprehension and trial, William Burke was publicly hanged on the morning of 28 January 1829 in front of a crowd estimated at between 20,000 and 25,000 and on the following day his body was dissected in the anatomy theatre of the University's Old College. Hare, who had been granted immunity from prosecution by giving evidence against Burke, was released in February 1829 and assisted in leaving Edinburgh.

The name of the pub has some historical precedent as Burke and Hare's crimes were known as the West Port Murders and many of the victims met their end in Burke's lodging on Tanner's Close which stood on the site of the nearby Argyle House.

28. THE BOW BAR, NO. 80 WEST BOW, VICTORIA STREET

The West Bow was the historic west gate of Edinburgh until the West Port was built at some time before 1509 – the Scots word bow (pronounced bough) means a port or gateway. Victoria Street was planned in 1827 as an access to the Grassmarket connecting to the lower part of West Bow.

The area is said to be haunted by Major Thomas Weir, the Wizard of the West Bow. Lanarkshire-born Weir moved to Edinburgh in the early 1600s where he became commander of the Town Guard following an impressive military career as a covenanting soldier. Weir was a devout Presbyterian and widely respected as such. He shared a property on the West Bow with his sister. To outsiders, it seemed that Weir had led a virtuous life. However, this view began to erode somewhat as Weir approached his seventieth birthday. The true nature of Weir's existence came to light in 1670 when the elderly major confessed his long list of sins to an astonished congregation. Weir admitted to decades of abhorrent behaviour and sexual depravity, which included incestuous relations with his sister and step-daughter, various other acts of fornication and adultery, and even bestiality with horses and cows.

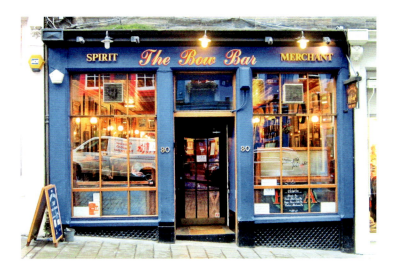

The Bow Bar.

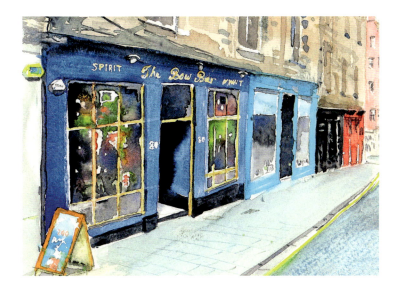

The Bow Bar by
Ross Macintyre.

Major Weir's sister Jean readily confirmed the shocking revelations. To make matters worse, Jean added further gravity to the situation by claiming that the Weirs had made a pact with the Devil and were guilty of countless acts of Satanism, sorcery and witchcraft.

Word of the Weirs' lurid crimes soon reached the ears of the city authorities who were quick to incarcerate the pair in the Tolbooth. The Weirs were tried on 9 April 1670. The major fully accepted his grim fate and refused to beg God for forgiveness as he declared 'Let me alone, I have lived as a beast and I shall die as a beast'. Weir was garotted and burned at the Gallow Lea close to modern-day Shrubhill.

Jane Weir was sentenced to be hanged at the Grassmarket. She was noticeably less gracious upon departure than her brother, wishing to die with all the shame she

could muster. Intent on creating a scene, she stripped herself naked while shrieking obscenities at the large crowd.

For some time after the executions, the Weirs' old house on the West Bow was considered off-limits. Nobody in Edinburgh dared step foot in the property for fear that it may be haunted or cursed. Even in the early nineteenth century, Sir Walter Scott maintained that the house possessed 'a gloomy aspect well-suited to a necromancer', and Robert Louis Stevenson admitted to suffering from nightmares in his childhood as a result of hearing the tale of Major Weir – who was now commonly referred to as 'the Wizard of the Bow'.

The Bow Bar has a huge range of spirits – stocking over 270 single malt whiskies – and has been voted the best whisky pub in Edinburgh. It also is regularly voted the Campaign for Real Ales's pub of the year for its excellent range of real ales. The interior of the pub is small with a traditional gantry and old advertising mirrors which were salvaged from other pubs and fitted at the Bow Bar in the 1980s. The beer is served from rare Scottish tall founts which use air pressure to pump the ale.

29. BANNERMAN'S, NO. 202 COWGATE

The Cowgate lies in a valley below the high ridge which forms the Royal Mile and is spanned by the South Bridge and George IV Bridge. There is some debate about the derivation of the name of the street – it is referred to in early documents as the Southgait (Sou Gait) and was also the route by which cows were driven on their way to pasture. It was a fashionable part of town in the sixteenth century, described as the place 'where the nobility and chief men of the city reside'. However, by the eighteenth century, it was one of the poorest parts of the city and in the nineteenth century was known as 'Little Ireland' owing its base as the home of the Irish immigrant community. It now hosts a large number of pubs and clubs and its popularity with late-night revellers is such that private cars are banned from driving along the street in the evenings

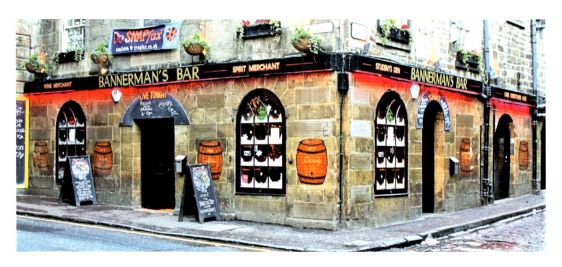

Bannerman's.

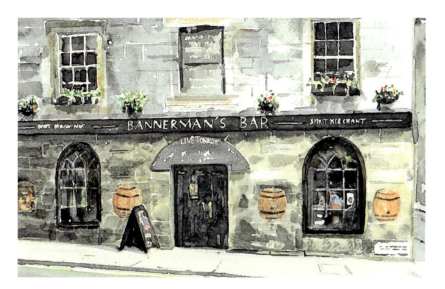

Bannerman's
by Ross
Macintyre.

Bannerman's occupies a warren of vaulted cellars a tall tenement that rises up multiple storeys to the South Bridge and perfectly illustrates Edinburgh's reputation as a 'braw hie heapit toun'. Plaques on the outside of the building include the names of previous occupants and their trades – haberdasher, flax dryer, tailor and pawnbroker. The pub is a popular music venue.

30. THE THREE SISTERS, NO. 139 COWGATE

The Three Sisters.

The Tailors' Hall.

Everything about the Three Sisters is huge – the cobbled courtyard with its 200-inch screen and the enormous bar areas that attract swarming crowds to the pub for its potent mix of drink and music. It is a fixture for the lively weekend stag and hen parties and is definitely not the place for a quiet drink and a look at the papers.

It would seem that hen night revelries are not a new phenomenon in the city. Robert Chambers in his *Traditions of Edinburgh* tells the story a group of eighteenth-century ladies who after a 'merry meeting in a tavern' and being 'no more clear-sighted as clear-headed' mistook the shadow of the Tron Kirk steeple cast by the moonlight for a wide river and proceeded to remove their shoes and stockings to wade over the imagined watery chasm.

The building that the Three Sisters occupies is amongst the most historically important in Edinburgh's Old Town for its association with Edinburgh's medieval guilds. It dates from 1621 and was built by the Incorporation of Tailors as their corporation hall. Parts of the building were also used for a number of other purposes over the centuries – a brewery, a printers, a theatre and a school. On 27 February 1638, between two and three hundred ministers met at the Tailors' Hall to prepare for the renewal of the Covenant, which was presented to the public on the following day. It was also used in 1656 as a court house by the Scottish commissioners appointed by Cromwell.

The origins of the pub's name date from the building's use as a theatre from 1727 to 1753. Legend has it that in 1741 three beautiful sisters, Cath, Kitty and Maggie Mackinnon, drew exuberant crowds to the theatre to witness performances of their accomplished singing and dancing. The incessant hostility of the clergy to the shows resulted in the theatre's licence being withdrawn by the town council. However, the sisters were eventually caught giving clandestine performances and were sentenced to death by being sealed into a room in the theatre.

The building was eventually sold in 1801 to the Argyle Brewery and was later used as storage by the University of Edinburgh. In 1998, the current bar and hotel were established in the premises.

31. THE CAVES, NOS 8–12 NIDDRY STREET

The Caves.

Norrie Rowan in the
Caves.

The Cowgate valley to the south of the Old Town ridge was a barrier to the development
of the southern suburbs. In 1785, the South Bridge Act authorised the building of a
bridge to span the gap. The foundation stone was laid on the 1 August 1785 and the
contract was given to the mason and architect, Alexander Laing, in February 1786
– plans by Robert Adam were rejected as being too elaborate. It was a monumental
engineering project – 1,000 feet long and 31 feet above the ground at its highest point

with foundations that penetrated the bed rock by 22 feet, and involved the clearing of three old closes. However, it was completed in just over two years and by July 1788 it was opened to traffic for the first time. It was originally intended that the first person to cross the bridge would be a lady who was its oldest resident. Unfortunately she passed away just before the opening day and it was her coffin that was the first thing to officially cross the bridge. This led to a superstition that the bridge was in some way cursed and many people in eighteenth century Edinburgh refused to use it.

The bridge consists of nineteen arches only one of which, the Cowgate arch, is visible. The others are hidden behind the buildings which line the bridge. The vaults at the lowest level of the bridge were originally used to house taverns, cobblers, a distillery and other trades. These businesses soon abandoned the vaults due to the windowless rooms, dampness and lack of sanitation. However, despite the appalling conditions, there is evidence that they were then used for a time as the very poorest housing. At some point in the nineteenth century, the vaults were filled in with rubble to discourage their use for nefarious purposes.

The vaults were rediscovered by former Scottish rugby internationalist, Norrie Rowan. Norrie spent a number of tireless years excavating tonnes of rubble by hand from the labyrinth of spaces and has since opened The Caves and The Rowantree bar venues in part of the vaults to the south of the Cowgate. In 1989, Norrie even helped Romanian rugby player, Cristian Raducanu, elude the Romanian secret police by using a trapdoor in the Tron Tavern which led to the vaults and allowed Raducanu to emerge several hundred yards away from the premises.

The Rowantree occupies the site of the eighteenth-century Lucky Middlesmass's Tavern. Lucky Middlemass's was famed for its oyster parties and the hospitality of the tavern is celebrated in this verse by Robert Fergusson:

> When big as burns the gutters rin,
> If ye ha'e catchit a droukit skin,
> To Luckie Middlemist's loup in,
> And sit fu' snug.
> Owre oysters and a dram o' gin,
> Or haddock lug.

32. GRASSMARKET PUBS

> Frae joyous taverns, reeling drunk,
> Wi fiery phizz and een half sunk,
> Behad the bruiser, fae to a',
> That in the reek o' gardies fa.

<div align="right">Robert Fergusson, 'Auld Reekie'</div>

The Grassmarket is the largest open space in Edinburgh's old town and an important focal point to the south of the Royal Mile. It is one of the city's most dramatic urban spaces: a long rectangle directly below Edinburgh Castle, providing a spectacular prospect of the southern cliffs of the Castle Rock. From 1477 to 1911, the Grassmarket was one of

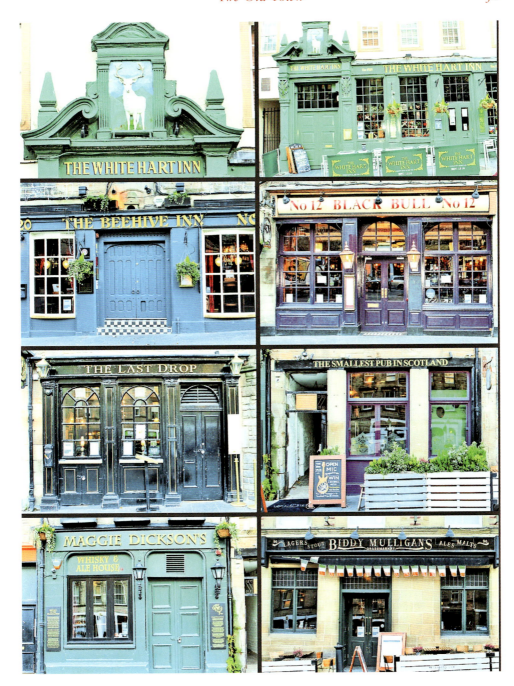

Grassmarket pubs.

Edinburgh's main markets for horses, cattle and corn. The area was dominated by taverns and lodging houses associated with the market business and this is still reflected in the seven closely packed pubs that line the pedestrianised north side of the Grassmarket.

The north-east corner of the Grassmarket was the traditional place of public executions. Sir Walter Scott described the Grassmarket gibbet in his 1818 novel *The Heart of Midlothian*:

> The fatal day was announced to the public, by the appearance of a huge black gallows-tree towards the eastern end of the Grassmarket. This ill-omened apparition was of great height, with a scaffold surrounding it, and a double ladder placed against it, for the ascent of the unhappy criminal and the executioner. As this apparatus was always arranged before dawn, it seemed as if the gallows had grown out of the earth in the course of one night, like the production of some foul demon; and I well remember the fright with which the schoolboys, when I was one of their number, used to regard these ominous signs of deadly preparation. On the night after the execution the gallows again disappeared, and was conveyed in silence and darkness to the place where it was usually deposited, which was one of the vaults under the Parliament House, or courts of justice. The last public hanging in the Grassmarket was in 1764, after which the gibbet was moved to the Lawnmarket.

Until fairly recently, the Grassmarket had a large number of hostels for the homeless and was generally associated with drunkenness. In 2009, the area was transformed by an environmental improvement scheme which pedestrianised the north side of the square and introduced a more continental feel with pavement café areas and bar sitooteries.

33. THE LAST DROP, NOS 74–78 GRASSMARKET

The Last Drop takes its name from its location close to the site of the Grassmarket gibbet and the execution theme continues inside.

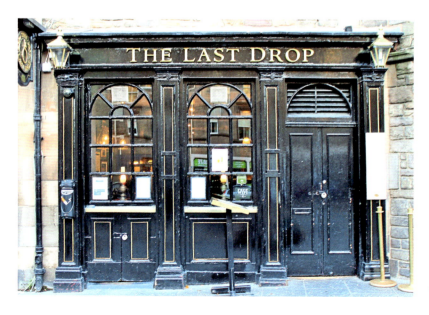

The Last Drop.

34. MAGGIE DICKSON'S, NO. 92 GRASSMARKET

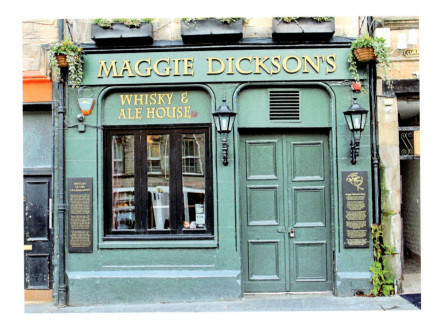

Maggie
Dickson's.

Maggie Dickson's overlooks the site of the Grassmarket gallows and the pub takes its name from one of the most famous executions on the site.

Maggie Dickson was born in Inveresk around 1702 and worked as a fish hawker. When her marriage to a local fisherman broke down, she moved to Kelso and found work at an inn. She fell pregnant by either the innkeeper or his son, but concealed her pregnancy and the birth of the child. Maggie abandoned the child's body on the banks of the River Tweed, where it was found and traced back to her. Maggie was arrested and tried in Edinburgh. It was never clear whether the child was stillborn or alive when born. However, the crime of concealing a pregnancy under a 1690 Act was considered as equally serious as murder at the time and both were capital offences. Maggie was found guilty and hanged in the Grassmarket in 1724. A broadside of the time detailed her execution in minute detail – how her legs were dragged down as she hanged for the allotted time. After fighting off the surgeon-apprentices, who were keen to have the body for medical research, her friends loaded her coffin onto a handcart to be taken back to Musselburgh for burial. When the funeral party took a short break for refreshments at an inn at Peffermill, sounds were heard coming from the coffin and when it was opened, Maggie was alive and, after a short rest, was able to walk home to Musselburgh. Maggie had suffered her punishment and could not be executed a second time. She lived on for many years after the event, had several children and was known forever after as Half-Hangit Maggie Dickson.

35. THE WEE PUB, NOS 94–96 GRASSMARKET

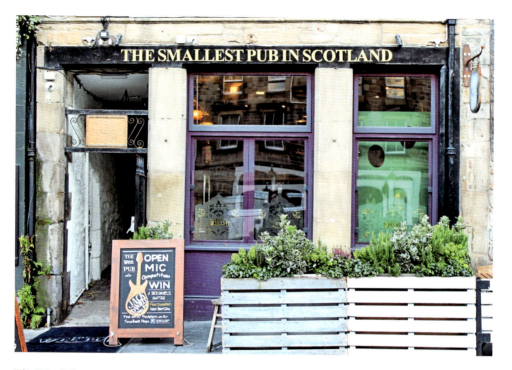

The Wee Pub.

Opened in 2013, the Wee Pub measures 17 feet by 14 feet, has room for twenty customers and has some claim to being the smallest pub in Scotland.

The pub occupies the ground floor of the building that was the home of the Grassmarket Mission. The Grassmarket Mission was founded by James Fairbairn in 1886 to provide the basic necessities of life to the many poor families that lived in the Victorian slums around the Grassmarket and the Cowgate. The Mission was later known as 'the Barries', from Alexander Barrie who was appointed as Superintendent of the Mission in 1916. The annual 'Barrie's Trips' involved thousands of local deprived children who were taken on a trip out of town for a picnic in the countryside. The Mission moved out of the building in 1989, but continues its community outreach work.

36. THE WHITE HART, NO. 34 GRASSMARKET

The White Hart Inn is the oldest licensed premises in central Edinburgh. There has been a White Hart Inn on this site from the early sixteenth century and parts of the cellar of the pub date from this period. The current building dates from 1740. The frontage is impressive with a striking entrance topped by an imposing carving of a white hart. Inside it is a traditional snug low-ceilinged place.

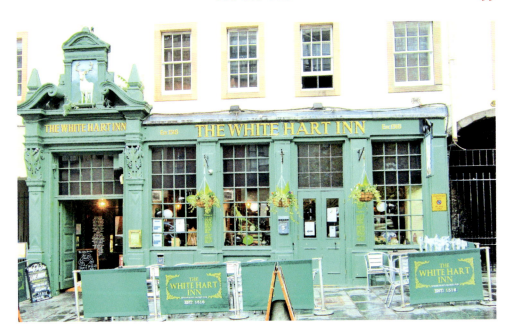

The White Hart.

The White Hart is the fifth most common pub name in the United Kingdom – a hart is an archaic word for a mature stag and was the personal emblem of Richard II. However, the name of the Grassmarket pub derives from a legendary incident in 1128 when King David was out hunting on the Feast Day of the Holy Rood (Cross). The King was miraculously saved from an attack by an aggressive stag when a fiery cross appeared between the stag's antlers. David is then said to have built Holyrood Abbey on the site of the incident.

The pub was a coaching inn, with the coach for Peebles advertised as departing from 'Francis McKay's, vintner, White Hart Inn', and provided accommodation and refreshment for the Highland drovers that brought their cattle to market at the Grassmarket. It was also popular with spectators at the public executions at the nearby Grassmarket gibbet.

The Grassmarket was one of the most run-down areas of the city and was associated in the nineteenth century with an influx of poor Irish immigrants – two of whom were the infamous Burke and Hare. Legend also has it that in the 1820s, Burke and Hare befriended a number of their victims at the White Hart before enticing them away to their nearby lodgings, where they were murdered.

On a more illustrious note, William and Dorothy Wordsworth took rooms overnight at the White Hart during their tour of Scotland in 1803 – Dorothy considered the facilities to be 'not noisy, and tolerably cheap'.

A brass plaque outside the pub is inscribed: 'In the White Hart Inn Robert Burns stayed during his last visit to Edinburgh, 1791'. Burns stayed at the White Hart for a week in November 1791 and visited his lover Nancy Macklehose (Clarinda) for one last time. During his stay he was inspired to write the great love song, 'Ae Fond Kiss'.

The White Hart is also rumoured to be Edinburgh's most haunted pub. Over the years there have been numerous reports from staff and customers of spooky activity – shadowy figures, doors slamming, beer barrels being inexplicably moved, taps being mysteriously turned on, loud banging noises from the cellar, bottles being thrown by an unseen hand and plates falling off shelves. On 31 October 2004, a group of investigators from the Ghost Club Council spent the night in the pub. They reported a number of strange occurrences and the investigators believed that something out of the ordinary was going on in the White Hart Inn. Their instruments recorded an electromagnetic field moving around the bar and a series of loud banging noises could not be explained. One of the investigators identified the presence of a female spirit who gave her name as Sally Beggs who died in 1772.

The White Hart suffered considerable damage caused by a bomb dropped during a German Zeppelin airship raid on the night and morning of 2/3 April 1916. The bomb landed on the pavement outside the pub and blew out windows on both sides of the Grassmarket, West Bow and West Port.

37. THE BEEHIVE INN, NO. 20 GRASSMARKET

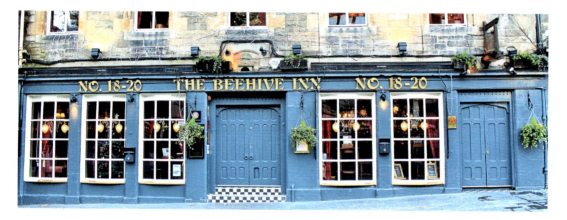

The Beehive.

There has been a pub called the Beehive on this site for over four centuries, although the current building is clearly marked 1868 on the first floor. It is a spacious pub with a main bar and seating/dining area on the ground floor; a restaurant on the first floor, with good views over the Grassmarket and a large beer garden at the back.

The entrance door to the first-floor restaurant was originally the door to the condemned cell at the Old Calton Jail. Calton Jail on the southern side of Regent Road received its first prisoners in 1817. It was a grim place – 'the poorhouse of all prisons with the cold chill of a grim fortress'. The jail was demolished in 1930 – with the exception of its southern wall and the governor's house which still exist today. The imposing art deco landmark of St Andrew's House, built in 1936 as the Scottish Office, now stands on the site of the Jail. Philip Murray, sentenced to death for murder

by throwing a man, who he had discovered in bed with his wife, out of a window on Jamaica Street was the last person to be hanged at the jail on 30 October 1923. The door that he would have walked through to meet his fate was moved as a rather macabre addition to the internal fittings of the Beehive, when the jail was demolished.

38. THE BLACK BULL, NO. 12 GRASSMARKET

The Black Bull in the Grassmarket was originally a much larger purpose-built inn with a pend access to stables at the rear.

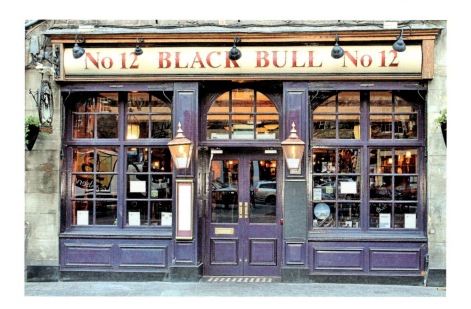

The Black Bull.

The original Black Bull.

South Side

39. SANDY BELL'S, NO. 25 FORREST ROW

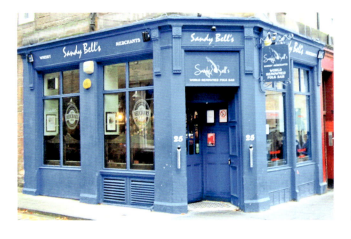

Sandy Bell's.

Sandy Bell's by Ross Macintyre.

Sandy Bell's started life as a local grocery shop. By the 1920s it was a pub owned by a Mrs Bell and going by the official name of the Forrest Hill Buffet and later The Forrest Hill Bar; although in recent memory it has always been known as Sandy Bell's – it is likely that Sandy was a barman at Mrs Bells' pub. In the early 1990s the signage on the pub was changed to Sandy Bell's.

The pub interior is a simple design with a substantial mahogany bar and is separated into front and back areas by a pedimented wooden arch.

Sandy Bell's claim to international fame is its association with the Scottish folk music revival of the 1960s and its continued use as a venue for live music. Jimmy Cairney, the landlord in the 1960s, was a devotee of traditional music. He encouraged young musicians to play in the pub and turned Sandy Bell's into one of the leading folk music venues in Scotland. Aly Bain, Barbara Dickson Phil Cunningham, The Dubliners, Dougie McLean, Gerry Rafferty, Billy Connolly, Rab Noakes, Dick Gaughan were just some of the people that started their careers at Sandy Bell's.

Sandy Bell's is still as lively as ever and remains a great place to hear the best in traditional music.

40. PEAR TREE HOUSE, NO. 36 WEST NICOLSON STREET

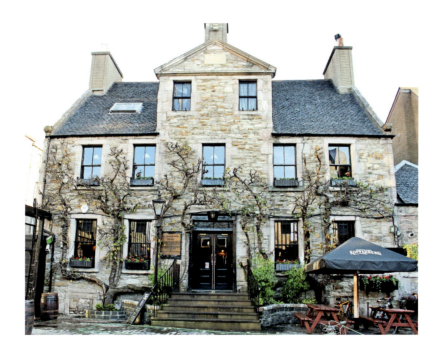

Pear Tree House.

Pear Tree House opened as a pub in 1982. The pub's major customer base is students from the nearby University of Edinburgh's George Square campus. The large beer garden, sheltered by a high stone wall, is an added attraction during the summer months when the sun does make an appearance.

The pub takes its name from the hundred-year-old jargonelle pear tree which grows over the west facing frontage of the building. The house dates from the mid-eighteenth century and the first occupant was Lord Kilkerran, a Court of Session Judge. Lord Kilkerran's son, Sir Adam Ferguson, who was the Member of Parliament for Edinburgh from 1784 to 1790, was the next owner of the house. Sir Adam entertained many eminent celebrities of the time at the house, with James Boswell noting in his journal that he 'drank tea at Sir Adam Ferguson's'. In 1823, the house was purchased by the brewing family of Andrew Usher as a family home and business premises. A room on the second floor has a glass cupola representing a miniature version of the dome of Edinburgh's Usher Hall, which was donated to the city by Andrew Usher in 1911. Prior to its conversion to a pub in the 1980s, the building was occupied by J. & G. Stewart, a firm of wine and spirit merchants

41. THE BLIND POET, NO. 32 WEST NICOLSON STREET

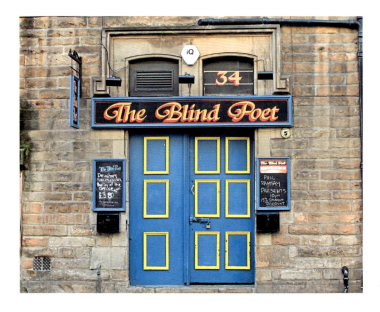

The Blind Poet.

The Blind Poet takes its name from Dr Thomas Blacklock (1721–1791), 'The Blind Poet', who lived in two upper floors of the building in the 1770s. Blacklock was born in Annan and was blinded by smallpox at the age of six. He studied for the ministry and moved to Edinburgh to work as a tutor. He was a moderately successful poet, but his main claim to fame is based on a letter he wrote to his friend, Robert Burns, Scotland's national bard, encouraging him to persevere with his poetry. The letter dissuaded Burns from emigrating to the West Indies, at a time when he had become disillusioned with life in Scotland. Burns noted that the letter roused his poetic ambitions. It also indirectly saved Burns' life, as the ship he had intended to embark on sank on the voyage. Long forgotten poems by Dr Blacklock decorate the interior of the pub.

42. THE CAPTAINS BAR, NO. 4 SOUTH COLLEGE STREET

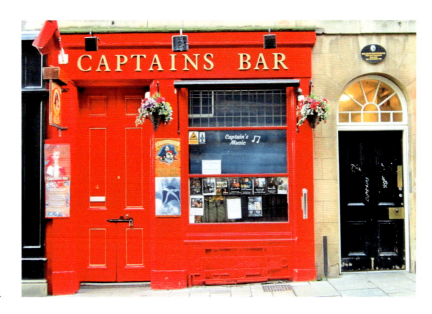

The Captains Bar.

The Captains or Captain's (the use of an apostrophe seems to be flexible – included on the projecting sign and omitted on the fascia) is a small friendly traditional pub with a long bar and splendid original wooden gantry. It has a reputation for live Scottish folk music sessions and is always busy.

The premises were originally used as a well-known tailor's specialising in uniforms for the ship captains of Leith and the name transferred to the pub when it opened in the mid-nineteenth century. At one time there was a staircase link to the pub from the adjoining Empire Theatre, allowing performers to grab a quick refreshment between acts.

A plaque above the door beside the pub announces that 'William McGonagall/ Poet and Tragedian/ Died Here/ 29 September 1902. William Topaz McGonagall (1825–1902), Scotland's celebrated greatest worst poet, lived above the pub from 1895 until his death in 1902'. Despite the quality of his poetry indicating that he was over fond of a tipple, McGonagall wrote a number of poems celebrating temperance. These are some selected verses from his poem 'The Demon Drink':

Oh, thou demon Drink, thou fell destroyer;
Thou curse of society, and its greatest annoyer.
What hast thou done to society, let me think?
I answer thou hast caused the most of ills, thou demon Drink.
Thou causeth the mother to neglect her child,
Also the father to act as he were wild,
So that he neglects his loving wife and family dear,

By spending his earnings foolishly on whisky, rum and beer.
And after spending his earnings foolishly he beats his wife–
The man that promised to protect her during life–
And so the man would if there was no drink in society,
For seldom a man beats his wife in a state of sobriety.
And if he does, perhaps he finds his wife fou',
Then that causes, no doubt, a great hullaballo;
When he finds his wife drunk he begins to frown,
And in a fury of passion he knocks her down.
The man that gets drunk is little else than a fool,
And is in the habit, no doubt, of advocating for Home Rule;
But the best Home Rule for him, as far as I can understand,
Is the abolition of strong drink from the land.
If drink was abolished how many peaceful homes would there be,
Just, for instance in the beautiful town of Dundee;
then this world would be heaven, whereas it's a hell,
An the people would have more peace in it to dwell
Therefore, brothers and sisters, pause and think,
And try to abolish the foul fiend, Drink.
Let such doctrine be taught in church and school,
That the abolition of strong drink is the only Home Rule.

43. RUTHERFORD'S, NO. 3 DRUMMOND STREET

Rutherford's is no longer a pub. However, it is such an important part of Edinburgh's public house tradition that it has to be given a mention.

It is famed as being one of Robert Louis Stevenson's haunts. Stevenson attended Edinburgh University, but was more attracted to an avant-garde lifestyle and spent much of his time in Rutherford's, across the road from the Old College. Stevenson was also a member of the University's Speculative Society whose weekly meetings would break for half an hour 'to buy pencils', a euphemism for a quick trip to Rutherford's for a refreshment. Stevenson noted that in Rutherford's he 'was the companion of seamen, chimney-sweeps and thieves and my circle was being continually changed by the action of the police magistrate'. The pub had such a nostalgic place in his memory that he wrote the following poignant lines in an 1888 letter from the South Seas:

And when I remembered all that I had hoped and feared as I pickled about Rutherford's in the rain and east wind; how I feared that I should make a mere shipwreck, and yet timidly hope not; how I feared that I should never have a friend far less a wife, and yet passionately hoped that I might; how I hoped (if I did not take to drink) I should possibly write one book. And then now – what a change! I feel somehow as if I should like the incident set upon a brass plate at the corner of that dreary thoroughfare, for all students to read, poor devils, when their hearts are down.

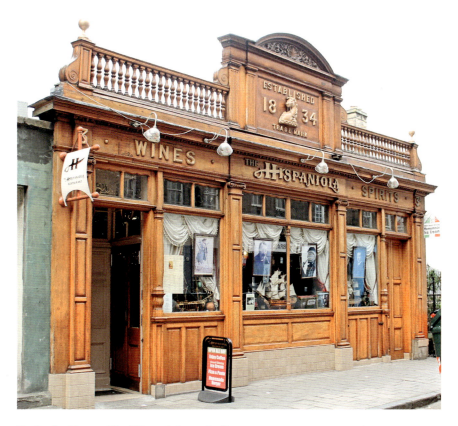

Rutherford's now The Hisponiola, an Italian restaurant.

His words were inscribed on a brass plaque close to the pub in 1995 and hopefully they will inspire generations of students to come.

An adjoining plaque, notes that Sorley MacLean and Hugh MacDiarmid, two giants of the Scottish literary Renaissance, first met in Rutherford's in 1934.

The pub was established in 1834 and the distinctive classical style timber frontage by J. M. Henry dates from 1899. A highly decorative central pediment over the frontage includes a horse figurehead and lettering: 'Established 1834/Trademark'.

The pub was converted into an Italian Restaurant, The Hispaniola, in 2007 and the owners are to be commended for making only limited changes to the frontage and maintaining links to Robert Louis Stevenson and other famous former patrons of the pub such as Arthur Conan Doyle and J. M. Barrie.

44. THE BRASS MONKEY, NO. 14 DRUMMOND STREET
Drummond Street is unusual in having two lost historic pubs. The predecessor to the Brass Monkey, over the road from Rutherford's, was Stewart's Bar (previously Fairbairn's) which even had its own personalised lamp post.

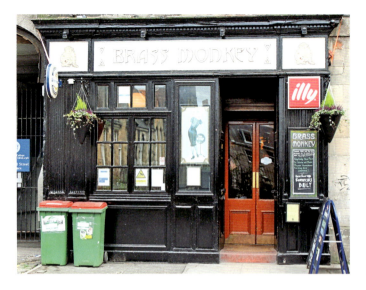

Left: The Brass Monkey.

Below left: Stewart's Bar.

Below right: Fairbairn's Bar.

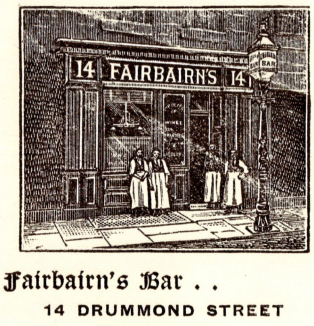

45. THE ROYAL OAK, NO. 1 INFIRMARY STREET

The Royal Oak is another pub on the South Side which is renowned for its folk music sessions. There are two very small bars, a lounge upstairs and the public bar at street level. These are particularly cosy on the regular music nights.

Infirmary Street got its name as the access to the Royal Infirmary which was built in 1738. The cellars of the pub, two floors below the bar entrance, still have cobbles

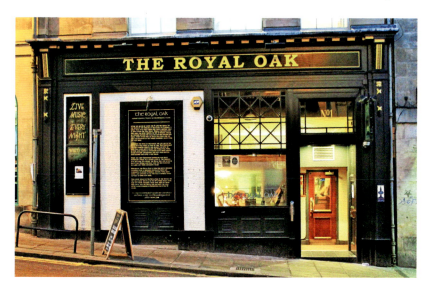

The Royal Oak.

and drains which are remnants of old Edinburgh and which, with the proximity of the Old Infirmary, are reputed to have been used by Burke and Hare to move the bodies of their victims.

The Royal Oak is the third most common pub name in Britain. The name derives from an oak tree in which Charles II hid to escape the Roundheads following the Battle of Worcester in 1651.

46. JEANNIE DEANS TRYSTE, NO. 67 ST LEONARD'S HILL

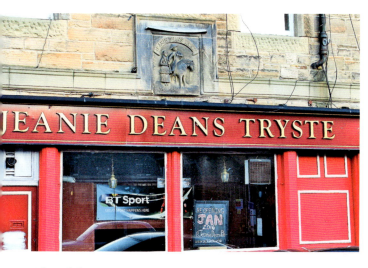

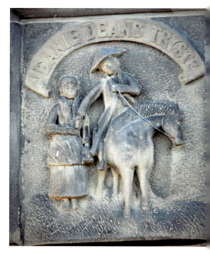

Above left: Jeannie Deans Tryste.

Above right: Jeannie Deans plaque.

Jeanie Deans is the heroine of Sir Walter Scott's 1818 novel *The Heart of Midlothian*. The character of Jeannie was renowned in the nineteenth century for the religious and moral convictions which she portrays in the novel. The plaque above the pub depicts Jeannie's meeting with the brigand, George Robertson, at Muschat's Cairn in Holyrood Park. The cairn, at the Meadowbank end of the Park, commemorates the spot where Nichol Muschat murdered his wife in 1720. His motive was simply that he had grown tired of her and he was hanged for the murder. A tradition developed of laying a stone at the site 'in token of the people's abhorrence and reprobation of the deed'.

A small house at St Leonard's which was long known as Jeannie Deans Cottage was demolished in 1965. There is a statue of Jeannie on the Scott monument and there are three pubs in Glasgow named the Jeannie Deans. Jeannie has also had ships, a locomotive, a rose and even a potato named after her.

47. LESLIE'S BAR, NO. 45 RATCLIFFE TERRACE

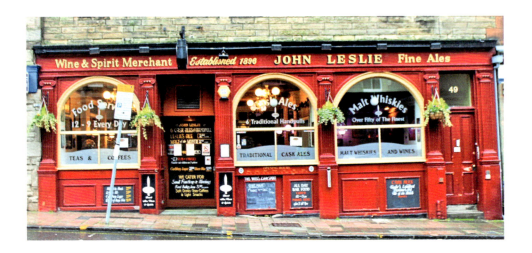

Above: Leslie's Bar.

Left: Ian Black, landlord of Leslie's.

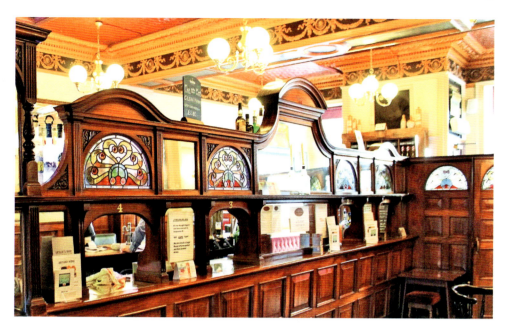

Leslie's Bar, the snob screen.

Leslie's Bar was originally fitted out on the ground floor of a four-story tenement building, which was designed by Peter Lyle Henderson and dates from 1895. The original landlord was Donald Cameron, but the premises were taken over by John Leslie, who ran the bar from 1902 to 1924, and it is his name that survives in the title of the pub.

The interior of the pub retains most of its original decorative features and layout – snug areas, a garlanded lincrusta frieze, ornate plaster cornices and ceiling roses, stained and leaded glass panels, mahogany timber panelling and a clock by the eminent Edinburgh clockmaker Robert Bryson.

The central island counter which runs the length of the pub divides the interior into two separate drinking areas – the public bar and the saloon bar. The bar gantry on the public bar side incorporates shelving, mirrored glass, semi-circular panels of coloured glass and distinctive numbered serving hatches. The inclusion of these hatches allows the gantry to act as a 'snob screen', with customers on the saloon side of the bar able to order drinks with a degree of privacy.

Tollcross

48. BENNET'S BAR, NO. 8 LEVEN STREET

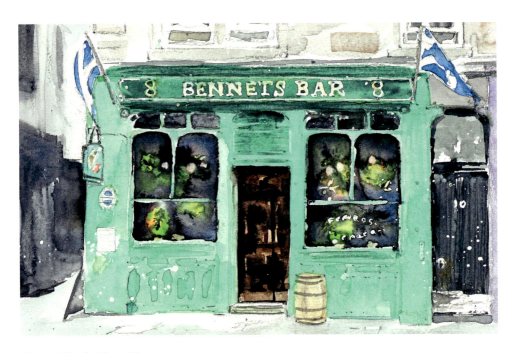

Bennet's Bar by Ross Macintyre.

The pub was designed in 1891 by George Lyle (Lyle and Constable) and was refitted in 1906, the same year that the adjoining King's Theatre opened and it remains a popular venue for theatre goers and thespians. It was originally known as Marshall's, a name which still appears on a sign on the gable wall and etched on the snug door.

The frontage is embellished with colourful decorative leaded glass windows and doors inscribed with brewery names ('Jeffrey's Lager & W. & J. Jenkinson's Bottled

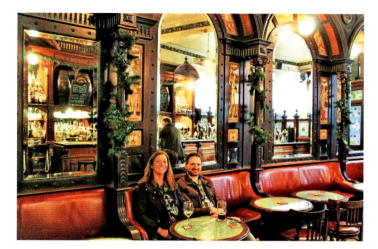

Bennet's Bar, mirrored wall.

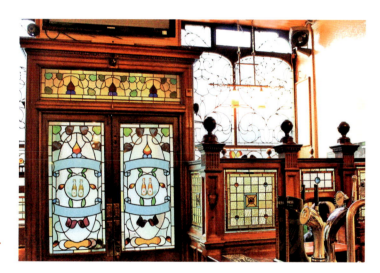

Bennet's Bar, stained glass at door and snug.

Beers & Aerated Waters, Leith') in gilded letters, which give a taste of the delights to come in the magnificent interior of the pub.

The splendid original bar has a wealth of ornate detail and is little changed since 1906. The small snug (jug and bottle) partitioned compartment, complete with its serving hatch, to the left of the entrance allowed a degree of privacy to the customers and is a rare surviving example of what was once a common feature in Scottish pubs.

The original bar counter runs the full length of the pub to the left of the entrance. The large collection of malts is dazzlingly displayed on a two-tier mirror-backed arcaded gantry embellished with niches, pilasters, urn finials and scallop shell pediments. The gantry also holds a rare set of spirit casks. The bar retains a now thankfully disused marble spittoon trough running the length of the counter and working brass water taps – a reflection of the Scottish preference for drinking whisky, the only spirit to be taken with water.

Opposite the bar there is a series of four fitted mirrors framed with hand-painted pictorial tiles of allegorical figures, by William B. Simpson & Sons of St Martin's Lane, London and carved wooden pillars behind fitted seats.

The outstanding interior is completed by coloured and gilded engraved advertising mirrors for Bernard's, Usher's, Campbell's, Taylor Macleod & Co. and Bell's Perth Whisky; an ornate timber chimneypiece with an enamelled cast-iron inset; floral glazed tiles and a heavily moulded compartmented ceiling.

49. MONBODDO, NO. 34 BREAD STREET

Above: The Monboddo.

Left: Lord Monboddo.

The Monboddo Bar occupies a building which was originally part of the principal department store of St Cuthbert's Co-operative Association.

Lord Monboddo was one of the most eminent and respected Judges at the Court of Session during the eighteenth century, but he was also something of an oddball. He had a passionate attachment to the ways of the Ancient Greeks and a contempt for anything he considered to be modern. As a result he lived very simply – if the Ancient Greeks didn't use it, neither did he. He travelled only on horseback, for example, as the coaches and sedan-chairs of the time were new inventions.

He refused to sit on the Bench with his fellow judges, but sat underneath with the court clerks – this was due to a decision which went against him in a case involving a horse.

In 1773 he published a notorious book, *Of the Origin and Progress of Language*. It included theories that man was descended from animals, that orangutans were related to humans and capable of speech, and that in the Bay of Bengal there was a nation of humans with tails. These ideas 'afforded endless matter for jest by the wags of the day', but today can be seen to be related to the theory of evolution. Even more eccentric was his belief that babies were born with tails and that midwives secretly cut them off at birth.

In 1785, when he was seventy-one, Lord Monboddo was visiting the King's Court in London when part of the ceiling of the courtroom collapsed. There was great rush from the building, until the danger was past and order restored. Lord Monboddo, who was deaf and short-sighted, was the only person who did not move from their seat. When asked why, he explained that he thought it was 'an annual ceremony, with which, as an alien, he had nothing to do'.

50. THE BLUE BLAZER, NO. 2 SPITTAL STREET

The Blue Blazer.

The Blue Blazer by Ross Macintyre.

A handy plaque on the frontage of the Blue Blazer details its history:

> This building was constructed in 1864 and was originally known as the Clan Alpine
> Buildings. The premises consisted of a corner shop on Bread Street, then known as
> Orchardfield Street, and a shop on Spittal Street owned by innkeeper, James Smith. In
> 1867, numbers 4 and 5 were bought for £900 from George Levack, wine and spirit
> merchant to extend the premises. The premises changed hands again in 1889 when
> John Sommerville a wine and spirit merchant from Quality Street in Leith bought it for
> £1,000. His first tenant James Flanagan named this licensed premises The Clan Alpine Bar,
> although it became more commonly called 'Flanagan's' after the character who ran it. For
> over 50 years from 1909, the property had a succession of owners and in 1960 brewers
> Scottish and Newcastle changed its name to what it is today – The Blue Blazer. Today you
> can experience quality cask conditioned beers and ales in the comfortable surroundings
> the 'Old Flanagan' would have felt at home in.

51. CLOISTERS, NO. 26 BROUGHAM STREET

Cloisters occupies the ground floor of the former three-storey Parsonage House for
the adjoining St Michael and All Saints Church. The building dates from 1878 and
was designed by the eminent architect Sir Robert Rowand Anderson. The building
is resplendent with gothic detail and the entrance to the pub is through an elaborate
pointed arch with an inset stained glass fanlight and lettering which reads: 'All Saints
Parsonage'.

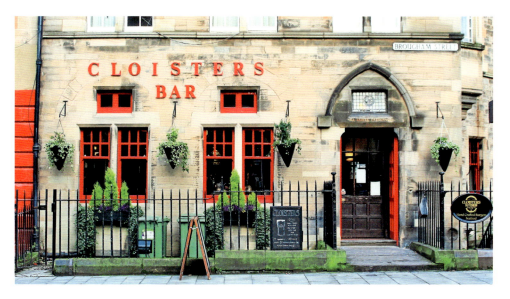

Cloisters.

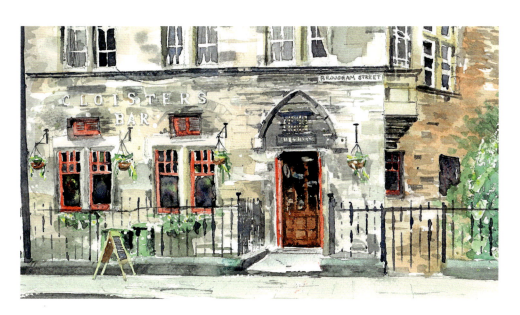

Cloisters by Ross Macintyre.

Bruntsfield/ Morningside

52. THE GOLF TAVERN, NO. 30–31 WRIGHTS HOUSES

The Golf Tavern.

The old Golf Tavern.

COCK OF THE GREEN.

Alexander McKellar and Willie Gunn.

The Golf Tavern is located on the western edge of Bruntsfield links and has a long association with the game of golf. Bruntsfield Links forms the last remaining fragment of the Burgh (Borough) Muir, which once stretched from the Borough Loch (South Loch) to Blackford Hill. There are records from 1599 of stone quarries on the site of the Links. However, much more importantly it was Edinburgh's first course for the pursuit of the royal and ancient game of golf.

Golf, already well known in Scotland around the middle of the fifteenth century, was so popular that it was at one time prohibited because it interfered with the practice of archery. Two pioneering clubs, the Royal Burgess Golfing Society and the Honourable Company of Edinburgh Golfers, were established at Bruntsfield in the mid-eighteenth century. Golf was so popular in Edinburgh at this time that the Town Council instituted a trophy, a silver club, as an annual prize for members of the Honourable Company.

A sign on the frontage of the pub claims that the business was established in 1456. However, the current building dates from the 1820s and the pub was refashioned in 1899 by Robert MacFarlane Cameron. It was used as the club house of the Bruntsfield Links Golfing Society from 1852 until 1894 and can lay claim to being the oldest nineteenth hole in the world. Legend has it that there was a tavern here which catered for golfers from as early as 1399 – there are records of a Golfhall Tavern opening in 1717 and a later Golf House Tavern, which was demolished in the mid-twentieth century.

The pub maintains its links to the game with a selection of golf related memorabilia and it maintains its club house status by providing clubs and balls for the adjoining Bruntsfield short-course.

Alexander McKellar, the 'Cock of the Green', and Willie Gunn were two golfing characters that no doubt would have been regulars at the pub's predecessors.

If among today's golfing enthusiasts there are many for whom the game is an obsession, it is unlikely that their condition is as acute as was that of one of Bruntsfield's eighteenth century players. Alexander McKellar, was the owner of an Edinburgh tavern,

the running of which he left exclusively to his wife who was often forced to send her husband's meals up to the Links. Immediately after breakfast McKellar would set off for Bruntsfield Links whatever the weather. He would golf for the whole day and even after dark would be seen playing by the light of a lantern. Despite his dedication and long hours spent on the course, McKellar apparently never achieved any great prowess at the game. Nevertheless, until his death in 1813 he proudly retained the title of 'Cock of the Green'. John Kay's portrait of Alexander McKellar playing golf is captioned: 'By the la' Harry this shall not go for nothing'.

If Alexander McKellar was Bruntsfield's most enthusiastic player, the most eccentric and odd character was Daft Willie Gunn, a regular caddie at the course during the early part of the nineteenth century. Willie's notoriety and reputation for daftness resulted from his habit of wearing all the clothes he owned at the same time. He would be seen in numerous layers of coats, hats, shirts and trousers whether it was summer or winter. To enable him to wear three or four jackets and coats, he would cut off the sleeves of all but the outer one. Apart from his unusual dressing habits, Willie would only ever eat bread and milk, never cooking food or having a fire in his lodgings even in the coldest weather.

53. THE CANNY MAN'S (VOLUNTEER ARMS), NO. 237 MORNINGSIDE ROAD

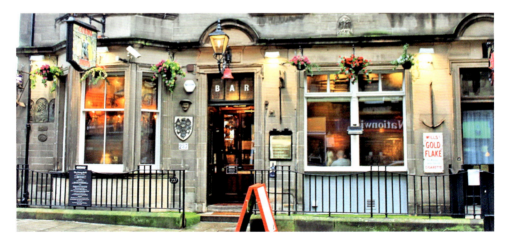

The Canny Man's.

James Kerr opened an inn in Morningside in 1871 and the Canny Man's, which occupied a two-storey villa dating from around 1890 and has been in the ownership of the Kerr family ever since.

The outside of the pub is festooned with a number of artefacts – an anchor, ornamental plaques, a sculpted head and a wagon wheel. This gives an indication of the decoration of the fine multi-roomed interior in which every nook and cranny is crammed with an eclectic collection of bric-a-brac, curiosities and memorabilia.

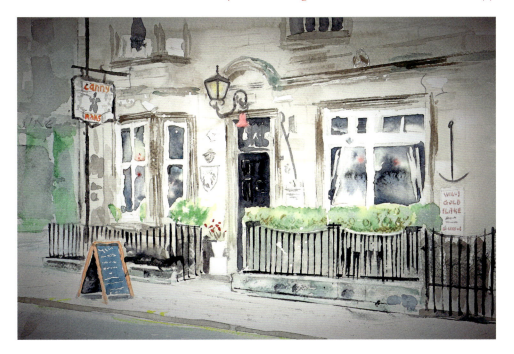

The Canny Man's by Ross Macintyre.

Watson Kerr was the renowned long-term landlord of the Canny Man's. His obituary in *The Scotsman* newspaper in September 2011 described him as an 'extraordinary Edinburgh publican whose unique approach to hospitality brought his Canny Man's pub legendary status'. It seems that Mr Kerr would refuse to serve customers if he didn't like the cut of their jib and banned Christmas revelers as they might disturb his regular clientele. His aim was to maintain proper standards in his pub.

The pub was originally known as the Volunteer Arms, a name which derives from the part-time soldiers that were created in 1859 for home defence following the Crimean War. The local unit was the Queen's Edinburgh Rifle Volunteer Brigade – the sign outside the pub shows a crouching rifleman and there is a painting of a kneeling volunteer by the artist Sam Bough in the bar.

Prominent brass plaques at the entrances to the pub read rather intimidatingly: 'no mobiles, no credit cards, no backpackers, no cameras' – so unfortunately there are no pictures of the inside of the pub, as I was too alarmed by this to ask permission. You'll just have to go there yourself for the experience.

54. BENNETS OF MORNINGSIDE BAR (WEE BENNET'S), NO. 1 MAXWELL STREET

Wee Bennet's is a modest well-preserved pub which was established by the original owner of Bennet's in Tollcross and is an interesting largely unaltered survivor from the 1960s. An unpretentious and restrained hostelry with a front patio area for a breath of fresh air or an al fresco fag.

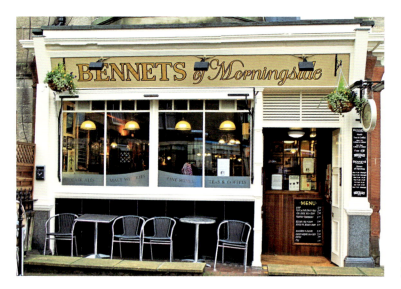

Bennets of
Morningside.

55. THE HERMITAGE BAR, NOS 1–5 COMISTON ROAD

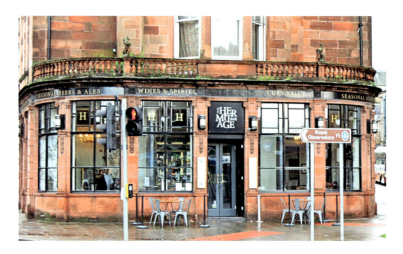

The Hermitage.

The Hermitage Bar is a traditional pub with a finely detailed frontage which occupies the ground floor of a huge prominent red sandstone building which dates from 1889. Much of the local area formed part of the Braid Estate and the pub and some streets in Morningside take their name from the Hermitage of Braid.

Morningside has the reputation of being on the prim and proper side, and there was a degree of controversy in the local community when the pub changed its name to the Morningside Glory – the *side* part of Morningside was underplayed in the signage and most people read it as the euphemistic Morning Glory. This generated a fair amount of publicity for the pub which has now reverted to its original title.

Dalry

56. THE ATHLETIC ARMS, THE DIGGERS, NOS 1–3 ANGLE PARK TERRACE

Above: The Diggers.

Right: Maria behind the bar at the Diggers.

The Athletic Arms is on the ground floor of a wedge shaped five storey tenement building dating from 1899 on the corner of Henderson Terrace and Angle Park Terrace in Gorgie. The name above the door of the pub is the Athletic Arms, but it is universally known as the Diggers taking its name from its historic popularity with gravediggers from the nearby Dalry and North Merchiston cemeteries. It is a popular venue for refreshment for Heart of Midlothian fans when the team is playing at Tynecastle.

For many years, the Diggers was famed for serving a high-quality pint of cask Heavy, McEwans 80s which was locally produced, and beer fans would make pilgrimages to the Diggers to sample this celebrated brew. The Diggers sold vast amounts – it was said that all you had to do was hold up the requisite number of fingers for the quantity of pints required and they would be immediately pulled by the bar staff. The Diggers took a quarter of the total output of the beer, but sadly, amongst some controversy, the production of the cask version of the beer was discontinued in 2007. The Diggers now has a substitute, Diggers 80s, which comes close to replicating the taste of its original Heavy.

The Diggers was owned by the T. W. Innes Trust from 1899 until ownership transferred to Scottish & Newcastle in the mid-1990s. A number of changes have been made since then, but the pub retains its traditional atmosphere with a substantial gantry, comfortable built-in red leather seating and a decorative compass motif inlaid on the floor of the bar.

Piershill

57. PORTERS BAR, NO. 7 PIERSHILL PLACE

Porters.

Porters Bar, formerly the Piershill Tavern, occupies the ground floor of a two storey building opposite the site of the former Piershill Cavalry Barracks. It is likely that there has been a pub on this site since the barracks were built in about 1794 and the pub would have been the local for the soldiers stationed at the barracks. The barracks were home to various regiments including the 6th Inniskillin Dragoon Guards and the 17th Lancers. They were demolished in 1938 and the site redeveloped as Piershill Square, using salvaged stone from the barrack buildings.

Piershill Barracks.

The present pub name derives from Andrew Porter who took over the pub in 1898. The pub has a particularly fine, well-preserved interior with decorative plaster cornices, a timber-panelled public bar, an arcaded Spanish mahogany gantry and compartmented ceiling.

Leith

58. PORT O' LEITH, NO. 58 CONSTITUTION STREET

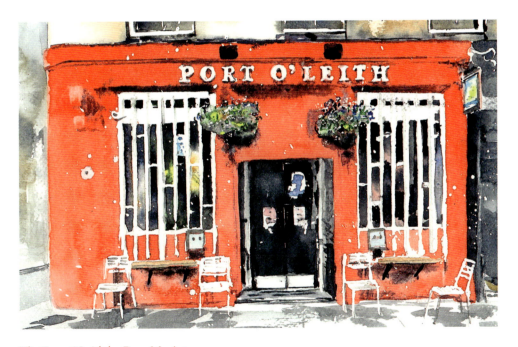

The Port o' Leith by Ross Macintyre.

The Port O' Leith pub was at one time the favoured hostelry of sailors calling in at Leith. The interior has a distinctive ceiling decorated with nautical flags and the walls are adorned with other maritime artefacts. The pub is said to be the model for the Sunshine Bar in Irvine Welsh's *Trainspotting* and features in the 2013 film *Sunshine on Leith*.

59. NOBLE'S BAR, NO. 44A CONSTITUTION STREET

Noble's.

Noble's Bar opened in 1898 and was designed for Archibald Noble by the architect William N. Thomson. Noble's has one of the most ornate frontages of any pub in Edinburgh. The central window is divided into three by carved timber mullions and the flanking entrances have oval–shaped panelling to the doors and large rectangular fanlights with stained glass panels depicting ship and fish themes.

60. BOUNDARY BAR, NO. 379 LEITH WALK

The Boundary Bar.

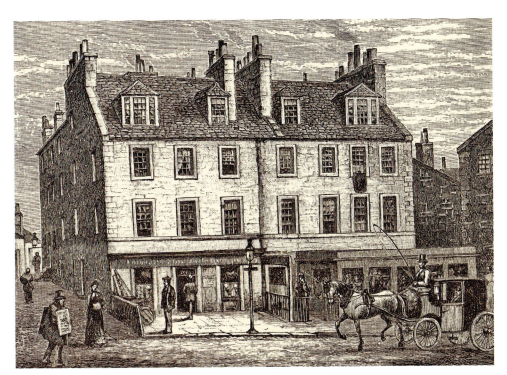

The old Halfway House.

The Boundary Bar on Leith Walk takes its name from its location on the historic dividing line between Leith and Edinburgh. From 1833 to 1920, Leith was independent from Edinburgh and a Municipal and Parliamentary Burgh with full powers of local government.

Edinburgh and Leith had quite separate licensing laws during this time and the Boundary adopted two sets of opening times. The bar had two separate entrances, one in Edinburgh and the other in Leith – customers on the Edinburgh side could be served until 9.30 p.m. and after that they had to move to the Leith side to enjoy some extra drinking time. It also seems that police from the two separate burghs would meet inside the bar to exchange prisoners.

The confusion inside the pub was reflected outside by what was known as the Pilrig Muddle. In 1905, when the newly created Leith Corporation Tramways pioneered the use of electric traction, an anomaly appeared that would take nearly twenty years and the unification of two separate autonomous burghs to sort out. Since Edinburgh's system was predominantly cable-run and Leith's electrified, passengers travelling either way along Leith Walk were forced to change vehicles outside the Boundary Bar, and no doubt a few passengers resorted to the pub for a quick refreshment. The merger of the two burghs in 1920 formed the catalyst for the upgrade of the Edinburgh network to an electric system. Electric trams finally crossed the frontier on 20 June 1922 and the chaotic interchange known as 'the Pilrig Muddle' was eradicated.

61. THE CENTRAL BAR, NO. 7–9 LEITH WALK

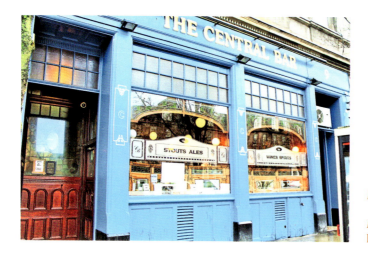

Left: The Central Bar.

Below: Inside the Central Bar.

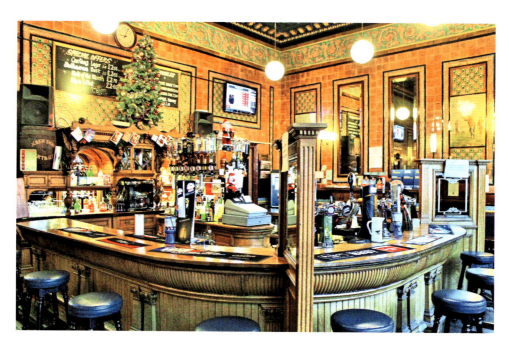

The prominent Italianate style building with a corner clock tower at the foot of Leith Walk, which is occupied by the Central Bar, was opened on 1 July 1903 by the North British Railway as Leith Central station, the terminal of the Leith branch of the line. The new station relieved Waverley of some of its suburban traffic and the seven-minute journey between Leith Central and Waverley, which cost one penny, was known as 'the penny jump'. The outstanding feature of Leith Central Station was its size, which

Central Bar tile
panels.

took up a complete town block running all the way through from Leith Walk to Easter
Road, most of which was covered by a huge steel framed roof.

The railway company offered John Doig, the proprietor of an earlier pub known
as the Central Bar at the junction of Leith Walk and Duke Street, larger premises in
the new building. The bar was completed in 1899, a few years ahead of the station
opening. The Central was the station bar and a stair at the rear of the pub provided
direct access to the station. This guaranteed a large number of patrons and no expense
was spared in the fitting out of the interior.

The largely unaltered highly-detailed decorative scheme is by Peter L. Henderson.
Two entrance porches, with mosaic floors, double-leaf timber doors and vivid stained
and leaded windows, provide access. The square bar has a high ceiling, with decorative
relief tiling by Minton Hollins of Stoke on Trent from the floor to the ceiling with
four inset panels showing sporting activities (yacht racing at the Cowes Regatta,
golf represented by a picture of the Prince of Wales, hare coursing and hunting with
pointers) and with tall, narrow and bevelled mirrors.

There is an elaborate plasterwork ceiling, U-plan fixed seating, a carved timber chimneypiece and a spectacular arcaded oak gantry with glazed display cupboards and four unusual carved gryphon figures.

Leith Central Station closed to regular passenger traffic on 7 April 1952, but continued to be used as a diesel maintenance depot until 1972 before its final closure. In its final years the derelict station was much used by drug addicts and the inspiration for the ironic title of Irvine Welsh's book *Trainspotting*.

62. THE KING'S WARK, NO. 36 THE SHORE

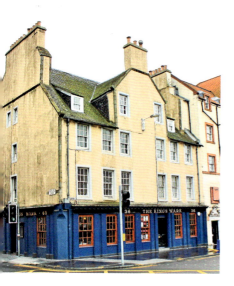 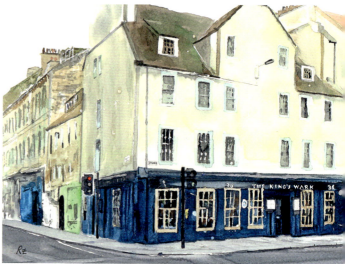

Above left: The King's Wark.

Above right: The King's Wark by Ross Macintyre.

The King's Wark has characteristic Dutch gables and scrolled skewputts in typical early eighteenth-century fashion. It stands on older foundations which were part of a much larger complex of buildings begun by James I in 1434 to serve as a royal residence with a store-house, armoury, chapel, and tennis court. The reputation of the pub, which occupies the building, was once notorious, and it was known locally as 'the Jungle'. It is now a much more salubrious establishment.

Duddingston

63. THE SHEEP HEID INN, NOS 43–47 THE CAUSEWAY, DUDDINGSTON

The Sheep Heid.

The Sheep Heid Inn with its cosy bar, enclosed beer garden, dining room and skittle alley is a popular place to stop-off for refreshment after a walk in Arthur's Seat.

The first inn on the site of the Sheep Heid is recorded as far back as 1360, making it the oldest continuous site of a public house in Edinburgh and possibly in Scotland.

The present building dates from the mid-nineteenth century, with an eighteenth-century core. The finely detailed Classical pub frontage is an addition of around 1900. The interior has been altered and refitted over the years, but retains its distinctive

Left: The Sheep Heid – skittle alley.

Below: Winter sports on Duddingston Loch, 1857.

Edwardian curved timber-panelled U-shaped bar counter. The gantry was altered in the late 1930s to house mirrors – 'Younger of Alloa the Best Beer Around'.

An old-fashioned skittle alley, with a timber gravity ramp for returning balls, is located in a single-storey building to the rear of the pub. The skittle alley is one of the earliest in the country.

There are two theories on the origin of the pub's name. The first relates to the gift of an ornate silver-mounted ram's head snuff box, with huge curling horns and eyes made

from semi-precious stones, which was presented to the landlord of the inn in 1580 by James VI in appreciation of the hospitality when he travelled between Craigmillar Castle and Holyrood Palace – Mary Queen of Scots was another royal patron. The snuff box was auctioned in 1888 when it was acquired by the earl of Rosebery and is on display at Dalmeny House.

The other relates to a local culinary speciality, sheep heid broth or powsowdie. Sheep were raised on Arthur's Seat from the medieval period to fairly recently. The sheep were slaughtered in abattoirs at Duddingston before being taken to the fleshmarkets of the Old Town. There being no great demand for the sheep heads, the people of Duddingston became well known for their innovative use of the perhaps less than tempting left-over in dishes such as sheep heid broth and singed sheep heid. Until the late nineteenth century Duddingston folk even used sheep skulls to pave their pathways.

It is recorded that the inn, was where 'many opulent citizens resorted in the summer months to solace themselves on one of the ancient homely dishes of Scotland – sheep heads, boiled or baked'. Sir Walter Scott and Robert Louis Stevenson frequented the pub and no doubt sampled a plate of powsowdie.

Mrs Beeton's recipe for sheep head broth is given below for anyone bold enough to try it:

Recipe – Sheep Head Broth (Potage de Tete de Mouton)

Ingredients: 3 quarts of water, 1 sheep's head, 2 carrots, 2 onions, 1 turnip, 2 strips of celery, a bouquet-garni (parsley, thyme, bay-leaf), salt, 1 tablespoonful of rice.
Method. Remove the brains and tongue, and soak the head in salt and water for 12 hours, changing the water repeatedly. Put it into a large saucepan with a good handful of salt, cover with water, bring to the boil, strain, and wash well. Return it to the saucepan, add the water, and bring to the boil, skim thoroughly, add a teaspoonful of salt, then simmer for three hours. Meanwhile cut the vegetables into dice, and now add them and the rice to the broth. Continue the cooking for another hour, then take up the head, cut the meat into dice and return it to the broth and simmer for a few minutes. Take out the herbs, add seasoning to taste, and serve. The brains can be used for brain cakes, and the tongue cooked and served separately. Only a small portion of the head need be served in the broth; the rest could be served separately, garnished with the tongue, and covered with brain sauce.

The Sheep Heid was used by members of the Duddingston Curling Society, which was formed in 1795 and soon became the most important curling club in Scotland. Many hard winters in the early part of the nineteenth century provided perfect conditions and the sport boomed. The membership fee for the Society was three guineas and the club attracted the most distinguished curlers from all over Scotland. The Society had a number of officials, including a poet laureate. There was also a salaried officer, equipped with a ladder and ropes, who was responsible for the safety of curlers on the ice. The Society was the first to introduce a membership badge and members who failed to wear it on the ice were fined a shilling. In 1803, the Society established the

first code of rules for the game, 'to avoid disputes and ensure harmony amongst the members'; and these were used as the basis for the rules of modern curling. They included fines for 'uttering oaths and introducing a political subject into conversation'. The Duddingston Curling Society flourished until 1853, when the game began to move indoors to artificial ice rinks.

The Sheep Heid continues as the venue for gatherings of the Trotters Club, members of which meet on the first Saturday of each month to play skittles. The Club originated around 1888 and the skittle prowess of one of their founders, William Drummond Young, is celebrated in this verse:

> See him tirr'd o' sark and breeks,
> Blobs o' sweat hap down his cheeks;
> The mightiest bowl behold him wale,
> And, swythe! like stooks afore the gale.
> The air is thick wi' wizzin' pins,
> The markers claw their barkit shins,
> When the thunderbolt is flung
> Frae the hand o' Drummond Young

Oxgangs

64. THE HUNTER'S TRYST, NO. 97 OXGANGS ROAD

The Hunter's Tryst.

An inn, called the Hunter's Tryst, is shown on this site on maps dating from the mid-eighteenth century. The name of the inn derives from its use by Scottish Kings and their entourage as a meeting place before hunting trips in the Pentlands. The pub is so long established that it has given its name to the surrounding area. In its early years the pub was run by two sisters, Betty and Katie McCone, and was famed for its excellent food. It was disused as a pub from 1869 until 1969, during which time it was used for various farming purposes, including a piggery.

The Hunter's Tryst main historical claim to fame derives from its use as the venue for meetings of the Six-Feet-High Club. The Club was established in 1826 and, as the name suggests, membership was restricted to people of six feet or more. The club was very particular that every candidate for admission was the required height. For this purpose, two of the managing committee acted as 'Grand Measurers'. Their main duty was to certify the height of every candidate for admission into the club. In order to prevent disputes, a standard measure was erected in the club-room, with a cross bar six feet from the ground, and adjustable only upwards. If a sheet of writing paper could be placed between the head of the aspirant for the honour of being a member, and the cross bar, he was declared 'wanting'. The number of members was restricted to 135, and generally they were resident in or near Edinburgh.

The club's activities centred on the practice and encouragement of athletics and gymnastics. The dress uniform of the club was 'the finest dark green cloth coat, double breasted with special buttons and a velvet collar – on special occasions, a tile hat was worn'.

The club also seems to have had a literary interest. Exceptions to the six-foot rule were made to grant honorary membership to Sir Walter Scott, who was the club umpire and referee in cases where a difference of opinion arose among the members, and James Hogg, who was the club's poet laureate. Sir Walter Scott's last appearance in public was when he presided at the annual dinner of the club. The Six-Feet-High Club and the Hunter's Tryst even get a section devoted to them in Robert Louis Stevenson's novel *St Ives*.

Queensferry

65. THE HAWES INN, NO. 2 NEWHALLS ROAD, SOUTH QUEENSFERRY

The Hawes Inn.

The picturesque Hawes Inn in South Queensferry dates back to the late eighteenth century and was originally built as the house of the Stewarts of Newhalls and was later known as the Newhalls Hotel (Hawes is local dialect abbreviation). It was used as a staging post for coaches with stables in the adjacent garage.

The Inn was made famous by Sir Walter Scott who mentions it in *The Antiquary*. It also has close associations with Robert Louis Stevenson who stayed at the inn in 1886, when he is said to have started penning his novel *Kidnapped* – it is from the Hawes

Newhalls Hotel.

that the hero of the book, David Balfour, is kidnapped. In 1887, in *Memories and Portraits*, Stevenson notes that:

> The old Hawes Inn at the Queen's Ferry makes a similar call upon my fancy. There it stands, apart from the town, beside the pier, in a climate of its own, half inland, half marine.